IMAGES
of America

MICHIGAN
OIL AND GAS

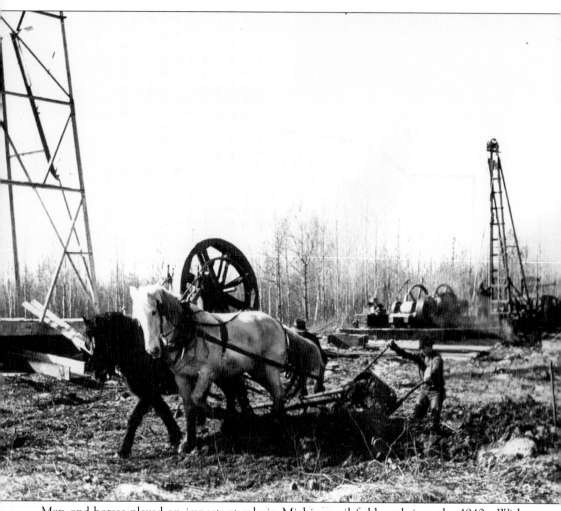

Men and horses played an important role in Michigan oil field work into the 1940s. With a standard derrick partly up and a water well machine working in the background, a slush pit is dug by man and team during Midland County's 1938 Edenville boom.

On the cover: Please see above. (Courtesy of the Clarke Historical Library, Norman X. Lyon Collection.)

IMAGES
of America

MICHIGAN OIL AND GAS

Jack R. Westbrook

ARCADIA
PUBLISHING

Published by Arcadia Publishing
Charleston SC, Chicago IL, Portsmouth NH, San Francisco CA

Printed in the United States of America

Library of Congress Catalog Card Number: 2006920845

For all general information contact Arcadia Publishing at:
Telephone 843-853-2070
Fax 843-853-0044
E-mail sales@arcadiapublishing.com
For customer service and orders:
Toll-Free 1-888-313-2665

Visit us on the Internet at http://www.arcadiapublishing.com

This book is dedicated to the men and women
of the Michigan oil and gas exploration
and production industry—then, now, and in the future.

CONTENTS

ACKNOWLEDGMENTS

The majority of the photographs in this volume are from the *Michigan Oil & Gas News (MOGN)* magazine files both in the publication's Mount Pleasant, Michigan, offices and comprising the Michigan Oil & Gas News Collection, and the Norman X. Lyon Collection, housed at the Clarke Historical Library on the Mount Pleasant, Michigan, campus of Central Michigan University where director Frank Boles, Pat Thelen, and the rest of the library staff have graciously prepared these photographs for publication. The biggest thanks is owed to Norman X. Lyon, who alternately edited MOGN and the Mount Pleasant *Daily Times-News* newspaper from 1929 to 1972 and left a photographic legacy to both the petroleum and the Mount Pleasant communities. Many thanks to the legion of photographers who have served the *Michigan Oil & Gas News,* which has published reports of Michigan oil and gas drilling activities and people weekly since 1933 and its current editor Scott Bellinger for continued access to the photograph files. Special thanks to the Michigan Oil And Gas Association and the association's longtime president Frank L. Mortl, a friend and employer for more than three decades.

INTRODUCTION

In 1925, the discovery of the Saginaw field marked the popularly accepted birth date of Michigan as a commercially producing oil state. The late 1920s through early 1950s proliferated with relatively shallow oil and gas field finds throughout the Lower Peninsula of Michigan.

The mid-1950s saw the discovery of the Albion-Scipio Trend, which, to date, has produced more than 125 million barrels of oil from a single reservoir, qualifying as a major oil field by worldwide definition. The late 1960s saw the discovery of the Niagaran Reef Trend, heralding the 1970s tripling of Michigan oil production and multiplying Michigan natural gas production six times.

The early-1980s discovery of deep strata natural gas production, still an emerging frontier, along with the potential of shallower zones and new technologies, signaled even greater production potential than any previous in Michigan's petroleum history.

The late 1980s and early 1990s were punctuated by an unprecedented upsurge of drilling activity in the shallow Antrim Shale of Northern Michigan.

With expanded Michigan market pipeline networks, Antrim Shale expanded development, and new horizontal drilling technologies, the 1990s ushered the state into a new era as a substantial natural gas production state. In the late 1990s, modern record-low wellhead prices of oil and natural gas devastated the petroleum industry in Michigan and nationwide.

The early 2000s found Michigan petroleum explorers maintaining abbreviated drilling programs while recovering from the price devastations of the late 1990s. In 2005, the number of holes drilled in the state continued coming "off bottom" from the record low of the year 2000.

Over 51,066 holes have been drilled in Michigan to date in the search for oil and gas, resulting in 14,782 oil wells, 12,663 natural gas wells, 3,005 facility wells, and 21,076 dry holes. From less than two percent of Michigan land area, 1.257 billion barrels of crude oil and 6.872 trillion cubic feet of natural gas have been produced from 64 Michigan Lower Peninsula counties.

Michigan citizens hold more than 8,000 jobs directly related to oil and gas exploration, production, refining, and transportation and related supportive supplies and services. Michigan private mineral owners currently receive over $196 million annually in royalties for oil and gas production from beneath their land.

The State of Michigan's oil and gas income from state-owned lands (royalties, rentals, and fees) has exceeded a billion dollars, not including severance taxes and oil and gas fees ($66.749 million in fiscal year 2004), in addition to the rollover effect on the Michigan economy of income, sales, and payroll taxes. Oil and gas royalties from state-owned lands fund the Michigan Natural Resources Trust Fund. Wellhead value of Michigan oil and gas production in the fiscal year ending September 30, 2005, was $1.341 billion.

Michigan petroleum exploration and production industry is the principal revenue source for the Michigan Natural Resources Trust Fund, which has funded the acquisition and improvement of 1,491 public recreation projects in Michigan worth over $672 million with royalties from oil and gas exploration and production activities on state-owned mineral properties since 1978.

Currently crude oil accounts for 22 percent of Michigan's principal mineral production while natural gas accounted for 29 percent, combining for over half of Michigan's mineral resources production. Michigan's geology provides the largest natural gas storage capacity of any state in the nation. This oil and natural gas production capability and natural gas storage capacity is important, since 47 percent of the U.S. population and more than half the nation's manufacturing capacity is within a 500-mile radius of Detroit. Continued and improved home-state energy production growth can be a key to sound Michigan economic expansion, as opposed to dependence on unstable outside energy supplies.

One

THE EARLY YEARS

The bowl-shaped Michigan geological basin is the sedimentary rock layered remains of an ancient tropical sea. These layers of formations are named for the place where that formation reaches closest to the earth's surface, or "outcrops." The Michigan Basin was the cradle of the worldwide petroleum industry when, in 1858, a hole was hand dug to 13 feet in the gum beds of Oil Springs, Ontario, (where Michigan's Dundee formation outcrops) and filled with free flowing oil. Later this well was deepened to 39 feet with a spring-pole rig. In 1859, Edward Drake drilled an oil well at Titusville, Pennsylvania, and began the process of drilling for oil. Michigan's first recorded oil field, the Port Huron Field in St. Clair County, was discovered in 1886 and produced local use petroleum, mostly for lubrication, from the same Dundee geological formation as Oil Springs, at about 575 feet. The last of the field's wells were plugged in 1921.

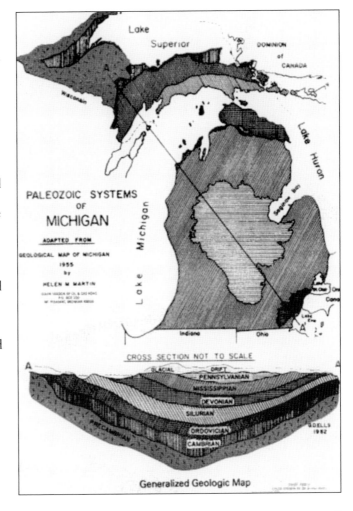

PALEOZOIC SYSTEMS OF MICHIGAN

ADAPTED FROM GEOLOGICAL MAP OF MICHIGAN 1955 by HELEN M MARTIN

CROSS SECTION NOT TO SCALE

Generalized Geologic Map

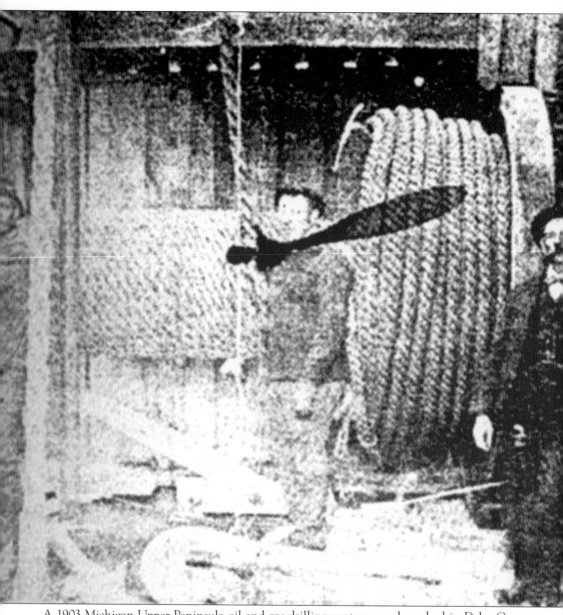

A 1903 Michigan Upper Peninsula oil and gas drilling venture was launched in Delta County by a well drilled to 1,000 feet with a bull-rope drilling line before abandonment. By the middle of the first decade of the 21st century, 29 holes had been drilled in the Michigan "U.P." in the search for oil and natural gas, all rated as "dry holes" (commercially unsuccessful). One exploration company reported oil "show" in a 2005 Upper Peninsula drilling attempt, but as yet no further drilling has been started in the area. This reprint of a reprint is reproduced from a 1940 *Michigan Oil & Gas News* reproduction of a photograph from a 1903 brochure.

Michigan's official beginning as a commercially productive petroleum state started with the August 1925 discovery of the Saginaw Field in the city of Saginaw. The same Saginaw Field well is shown above in the early 1930s and below in the 1980s. In Michigan, some families of mineral property owners are in the fifth generation of petroleum production royalties from oil and natural gas output from beneath their lands.

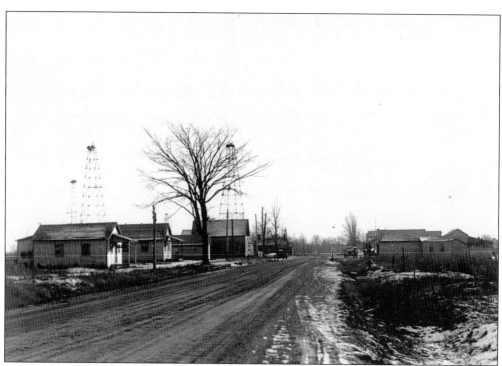

The more prolific, some say more significant, Muskegon Field, discovered in 1927, put Michigan solidly among commercial oil and gas states. The 1928 discovery of the Mount Pleasant Field between Mount Pleasant and Midland, by Pure Oil Company, proved that commercial oil production "inland" in the Michigan mitten was possible. The company established a work and living complex for workers, with nearby businesses the basis for today's Oil City, Michigan.

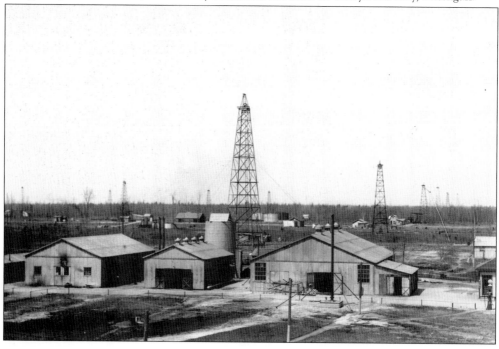

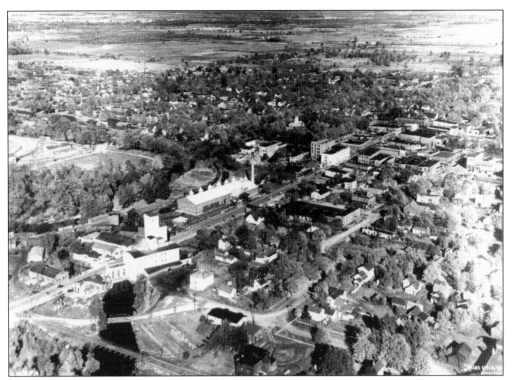

Through the efforts of Mount Pleasant resident Walter Russell in securing pipeline right-of-way from the Mount Pleasant Field to the railhead at nearby Mount Pleasant, the town (above in the early 1930s) became a center of Michigan oil and gas exploration activity and refining (Roosevelt Refinery below) and is known to this day as "the Oil Capital of Michigan."

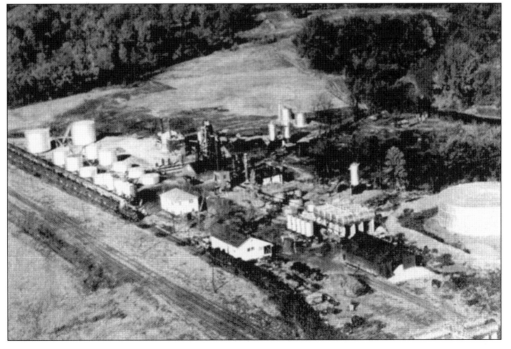

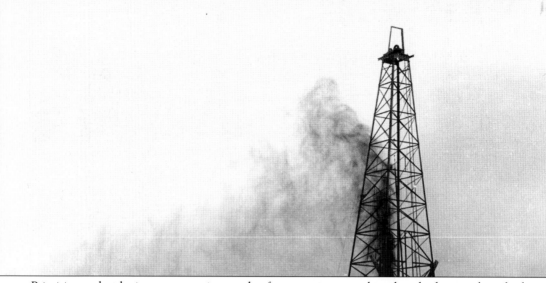

Primitive technologies, conservation, and safety practices, combined with the novelty of oil discoveries in Midland, Isabella, and Muskegon Counties, made "bringing in" a well in the 1920s and early 1930s a spectacle. Big crowds of investors, potential investors, townspeople, reporters, and petroleum explorers' families turned out to "see the well come in"; an awesome if now outdated wasteful and dangerous method of showing off a successful drilling project. For aesthetic and energy conservation reasons, the gusher has been a thing of the past for more than half a century. This fact has escaped the film and television media, who still symbolize a successful well with the archaic and foolish gusher, since it is more dramatic and photogenic than the twitch on a gauge; the true way a modern well "comes in."

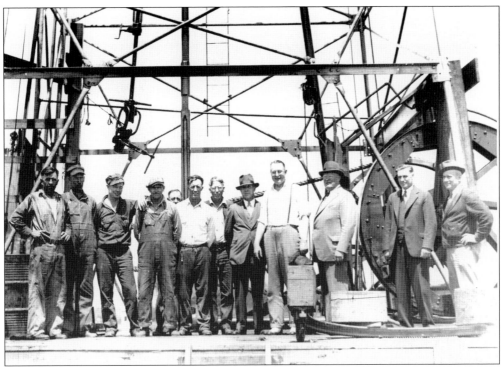

The "drill-in-as-a-carnival" practice had lethal results July 18, 1931, when the Walter J. McClanahan's Struble 1 well "blew out" and exploded while the site was crowded with well-wishers in Greendale Township of Midland County. Ten people were killed (including McClanahan's wife) in Michigan's worst oil field disaster. McClanahan is in shirtsleeves, fourth from the right above.

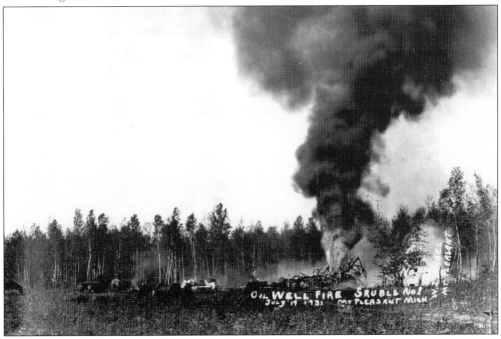

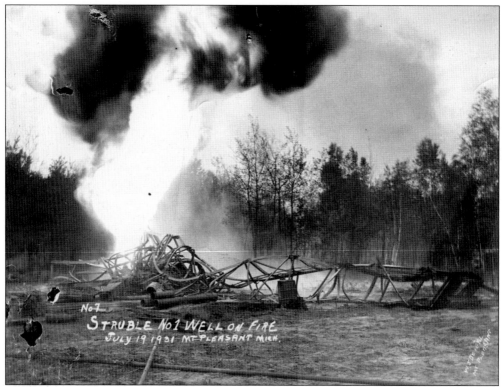

The twisted rubble, all that remains of the drilling rig of the McClanahan Struble 1 seen above, remains white hot and must be cleared by the tractor below to avoid reignition of the escaping natural gas once the fire was extinguished.

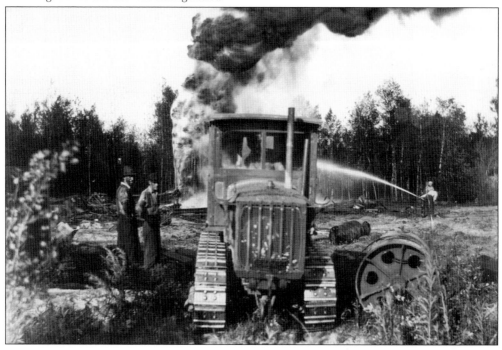

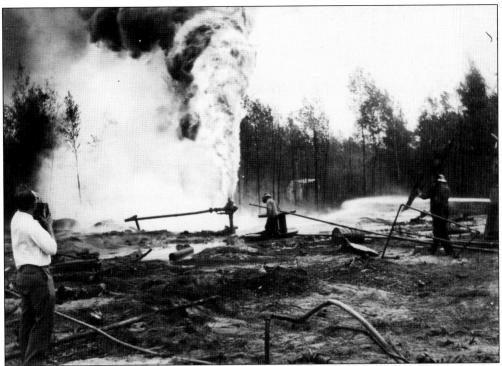

The cleaning of smaller pieces of Struble 1 well rubble is finished by hand, above, and hose crews move in to extinguish the burning natural gas and turn the valve off to bring the blowout under control by stemming the gas flow. Of the more than 50,000 wells drilled in the search for Michigan oil and gas, 99.99 percent have been drilled without incident.

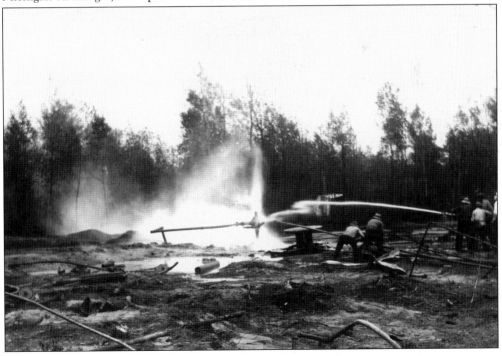

The Porter Field played an important role in early experiments to increase oil flow. Because the porosities of oil bearing rock can vary, oil or natural gas sometimes flows very easily through the stone while in other reservoirs the flow is more difficult. One way to accomplish an increase in porosity, stimulating oil, and gas production is to pump acid into a well, which is particularly successful when used on limestone or other rock easily dissolved by acid. On February 11, 1932, the world's first acidizing treatment to stimulate well production was accomplished on the Pure Oil Fox No. 1, Chippewa Township, Isabella County (in the Mount Pleasant Field). Legend has it that the acid was injected with a garden hose borrowed from a worker's home. Dowell, a major firm involved in oil well stimulation, was born.

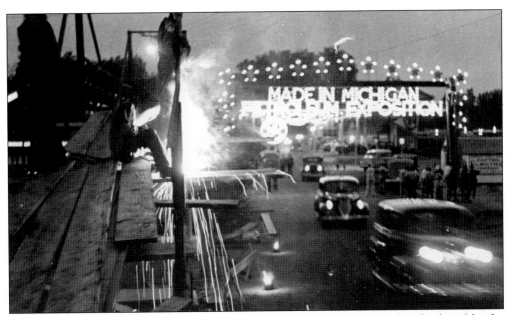

Workmen complete a footbridge for walkers into the Mount Pleasant Island Park, above, for the first Michigan Petroleum Exposition in 1935. The exposition drew more than 25,000 visitors and was repeated in 1936 and 1937 before dwindling crowds brought the event to an end. Each exposition featured a working drilling rig, below, actually making a hole, that was raffled off at the end of the show.

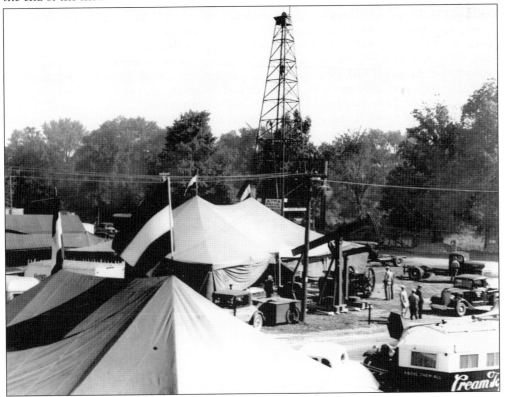

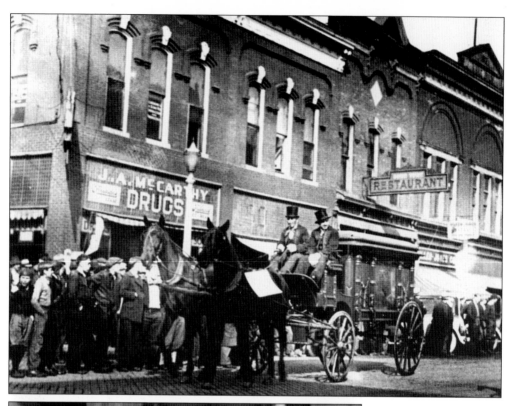

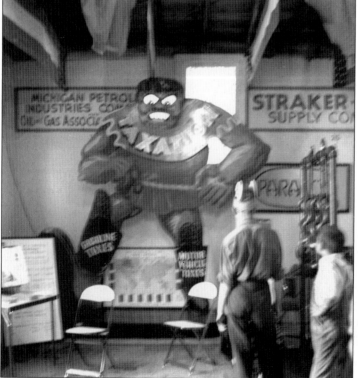

The 1935 Michigan Oil and Gas Exposition opening parade, above, was led by a hearse carrying an effigy of "Old Man Depression" honoring the oil business for shielding the Mount Pleasant economy from the Great Depression. The Michigan Oil And Gas Association (MOGA) booth at that exposition featured "the tax and regulation monster."

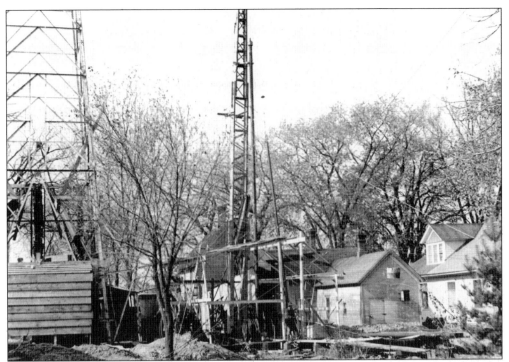

Petroleum drilling spread to 23 counties, with 7,348 holes drilled, resulting in 2,505 dry holes, 4,229 oil wells, and 614 gas wells by the end of the 1930s. No well spacing or production controls existed, causing exploration encroachment on populated areas like Bloomingdale, where 45 wells were drilled in the 80 acre village, and economic waste by too many wells pulling from the same source, limiting overall recovery.

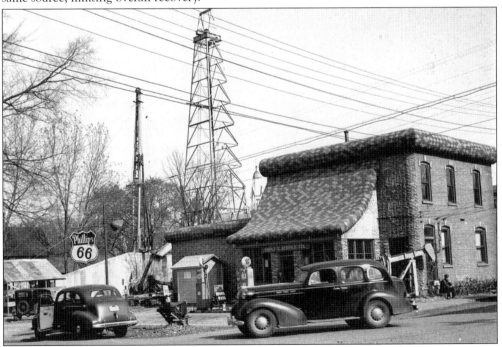

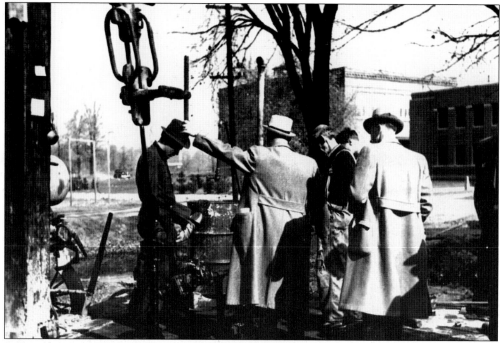

Before 1939, town lot drilling in Van Buren County's Bloomingdale, above, and Kent and Allegan counties, below, caused aesthetic and economic problems from well crowding, which does not efficiently drain oil and gas reservoirs. This led to the passage of Act 61 of 1939, Michigan's Oil and Gas Law, considered classic oil and gas regulation to this day, which established minimum well spacing and prorated production levels.

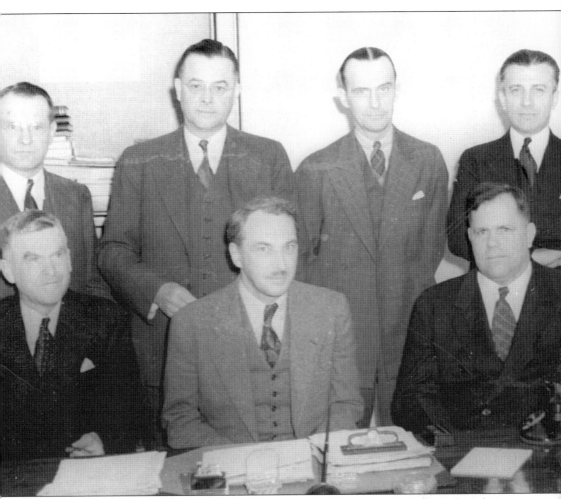

The implementation of the Michigan Oil and Gas Law called for the establishment of an advisory board comprised of regulatory and industry experts to review oil and gas issues and give input to the supervisor of wells. Act 61 was revised often to keep up with emerging technologies and technical knowledge. In the 1970s, citizen members were added to the board, and in 1994, Act 61 was replaced by Act 451, the Natural Resources and Environmental Protection Act, requiring an oil and gas advisory committee. Michigan's first oil and gas advisory board members are, from left to right, (first row) W. P. Clarke, Department of Conservation director/supervisor of wells P. J. Hoffmaster, and MOGA president Harold M. McClure Sr.; (second row) C. A. Smith Jr., Edward Clagett, Russell Furbee, and Kurt deCousser.

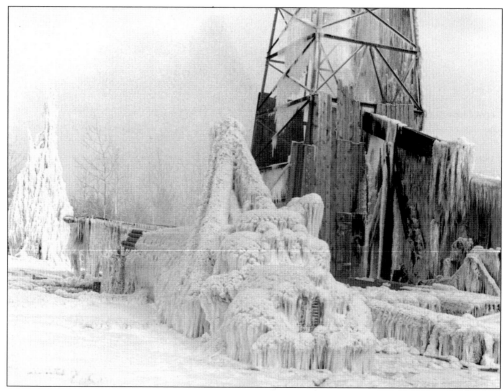

Weather conditions were not always kind to the oil patch. In Mecosta County's Fork Field a well blew fresh water and froze in 1944 (above). Cleanup took three weeks. Leonard Oil Company supervisor Robert Bloomer (below) cooled off by hanging his coat on a telephone wire on the way to a Montcalm County well in the winter of 1946–1947.

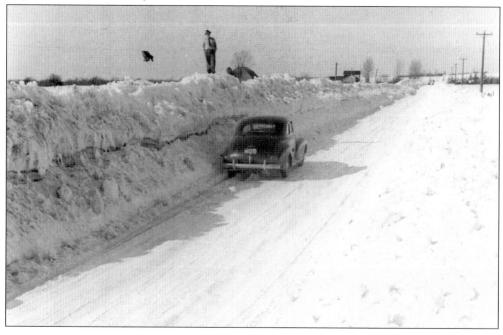

Snow-slowed goings, to and from the Michigan oil fields, have been a perennial problem from the beginning, as in Missuakee County, right, and Gladwin County, below. Modern, highly mobile drilling rigs and more sophisticated hauling equipment have lessened the paralyzing effect of snow. Oil field activities are still sometimes shut down by Michigan winters, giving drilling crews unexpected downtime not experienced by their southern cousins.

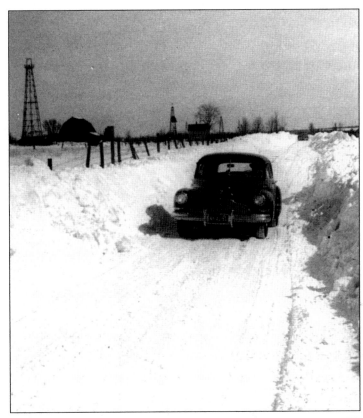

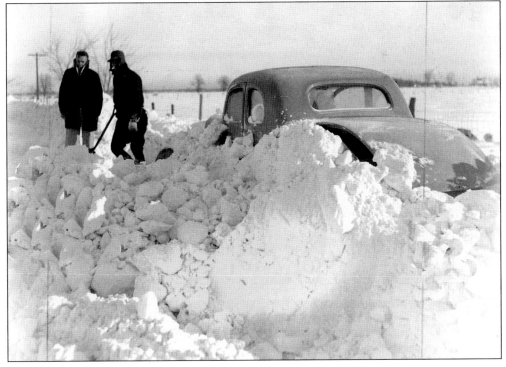

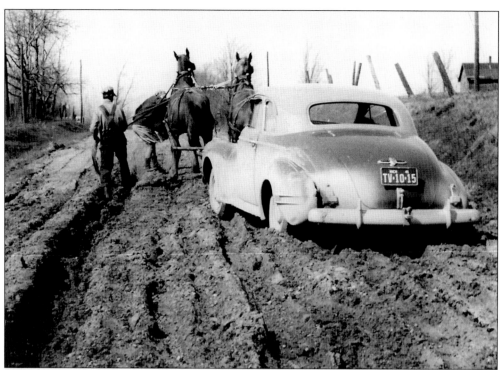

Springtime was not much kinder and many an oilman found his iron steed at the mercy of horses when spring thaw brought the frost from the ground and left remote areas a sea of mud as in Clare County, above, and at this drill site in Muskegon County, below, where men and equipment had to "hoof it" in to the well site.

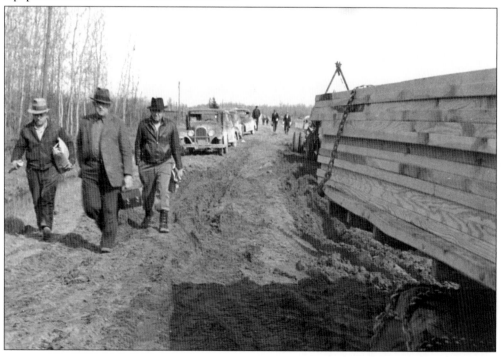

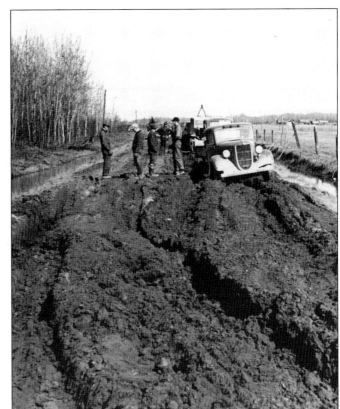

Spring brings road load restrictions to avoid damage to state byways caused by the hauling of heavy equipment across melting frost softened roadbeds. Off-road, on lease roads, below, spring travel is no fun either as in the 1930s Gladwin County scene, right, and 1993 Otsego County.

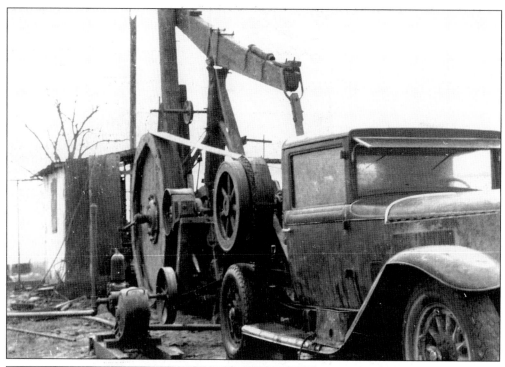

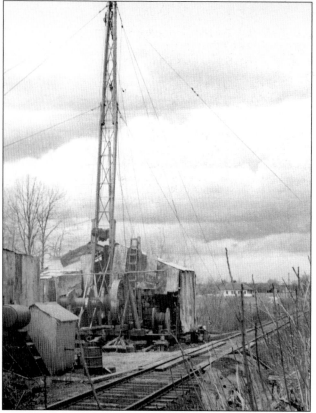

Ingenuity found a way in the early oil fields, where finding efficient power to operate oil and gas drilling and production equipment was often difficult in remote locations. A truck was used as a pumping unit power source, above, on a 1930s Gratiot County well. In Newaygo County, left, off-loading equipment shipped by rail was no problem for this driller.

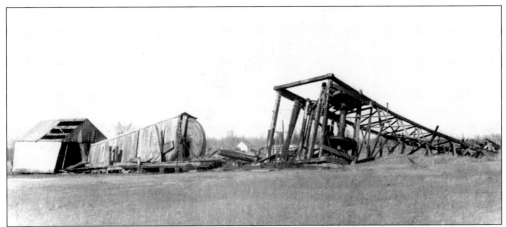

The winds of Michigan caused havoc for wooden and steel derricks alike in the early days of the state's oil and gas development. Derricks, named for the 17th-century British executioner who invented them for other purposes, are needed to lift and lower sections of drill pipe from the oil and gas well bore. Modern derricks are seldom blown over as were these in 1930s Montcalm, above, and Osceola Counties.

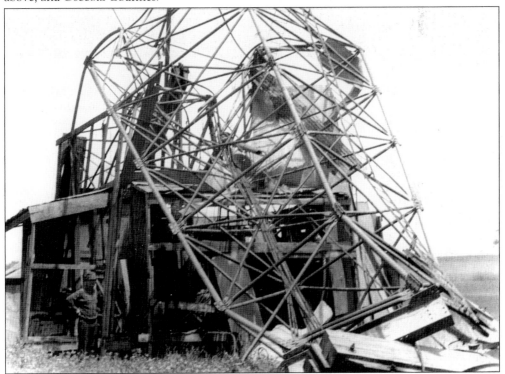

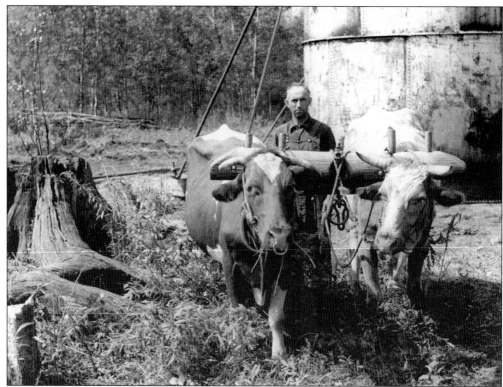

World War II brought rationing of gasoline and a shortage of manpower to many facets of life, seriously abbreviating activities of two facets of harvesting the bounty of the Michigan soil. In 1943, above, oxen were borrowed from farm duties in Montcalm County to move equipment on a well location. In St. Clair County, below, farm operations continued around drilling activities.

Two

THEN AND NOW

In the Arenac County Clayton Field, a modern rotary rig drills a deep zone well to the Prairie du Chien geologic formation in search of natural gas at 10,614 feet in 1994, while a nearby pumping unit in the foreground continues to pump oil from a shallower well drilled in 1947 to the Richfield geological formation at about 3,790 feet.

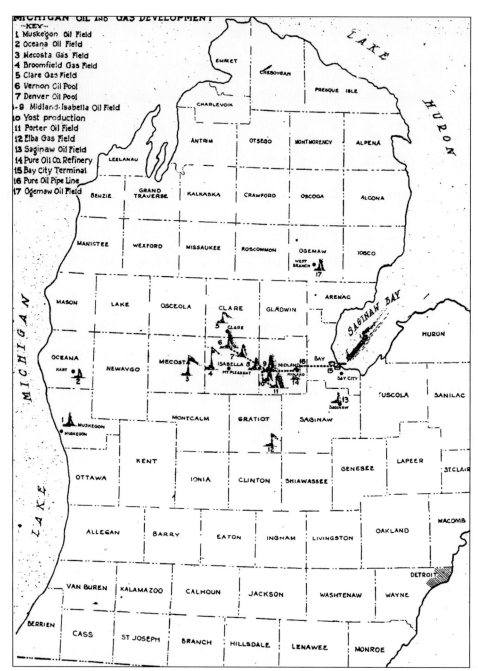

This November 1933 oil and gas development map of Michigan lists 17 points of interest: Muskegon Oil Field, Oceana Oil Field, Mecosta Gas Field, Broomfield Gas Field, Clare Gas Field, Vernon Gas Field, Denver Oil Field, Midland/Isabella Oil Field (counted as two fields), Yost production, Porter Oil Field, Elba Oil Field, Saginaw Oil Field, Pure Oil Refinery, Bay City Terminal, Pure Oil Pipeline, and Ogemaw Oil Field. Note that the majority of this activity was defined by good roads at the time. A Michigan geologist once commented that if a 1950s road map was overlaid on 1950s Michigan oil and gas field map, most of the field activity would be very near to good highway access.

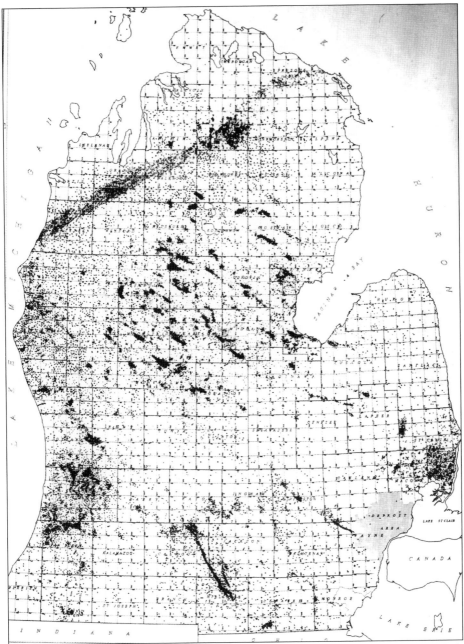

A modern Michigan oil and gas well map shows the result of drilling more than 50,000 holes in the search for oil and gas, with more than half of those holes dry, or non-commercial. Michigan oil and gas is produced from 64 of Michigan's 68 Lower Peninsula counties. Note the arched sweep in the upper portion of Lower Michigan, indicating the Niagaran geological formation pinnacle reef trend and, later, the shallower lower volume natural gas wells drilled to the Antrim Shale formation. Together the oil and gas production from the Niagaran formation and natural gas production from the Antrim took Michigan from producing about two percent of the oil and three percent of the natural gas it used in the 1960s to four percent of the oil and 26 percent of the natural gas the state uses in the early 2000s.

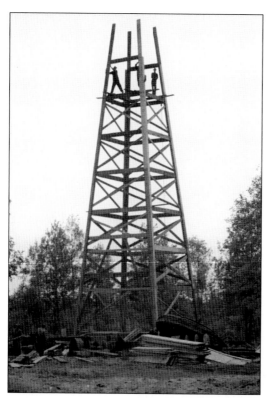

Michigan petroleum exploration saw wooden derricks, as seen at left in Isabella County, constructed to raise and lower the drill bit and sections of drill pipe in the hole being drilled. Stronger steel later became the derrick builder's material of preference, as seen below in Arenac County. Wooden and steel derricks stayed permanently on the location. All of the wood and most of the steel Michigan derricks have now disappeared or been removed.

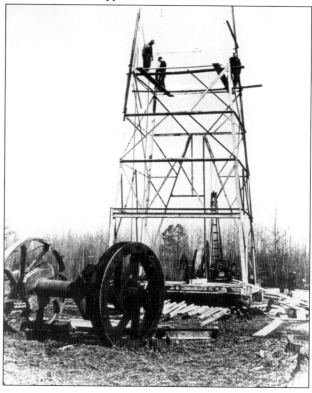

Efficiency in movement and material came to drilling operations with development of portable jack-up drilling rigs, as seen at right in Jackson County. Mobile drilling rigs, seen below in Bay County, became common in the field. Early drilling was done using the cable tool method, which speared through the earth with a pounding motion. The 1940s brought the speedier rotary drilling method, using a drill bit to grind through rock.

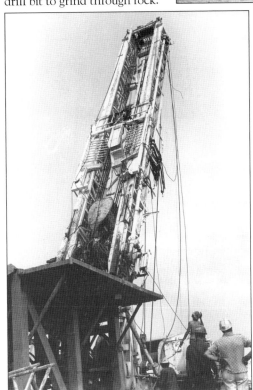

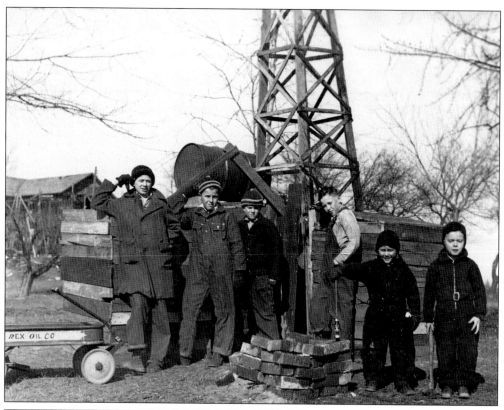

Depression-era kids found entertainment in modeling backyard play structures after the rigs they saw bringing welcome income to their area. Above, in 1936, Montcalm County's Lakeview kids built a replica well site. From left to right are Ellis Linscott, Jamie Linscott, Jimmy Linscott, Bud Linscott, James Waiff, and Carl "Pudding" Goff. In 1939, at left, 12-year-old Earl "Red" Perry Jr. built a miniature cable tool drilling rig in his back yard.

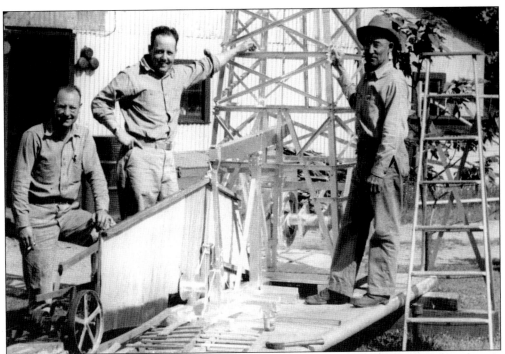

Building models of drilling rigs was not the exclusive territory of kids. In 1946, Straker Supply employees, seen above from left to right, Walter (Wally) Holecheck, William Stewart, and Howard Watter, built a model cable tool rig in the company's front yard. The late Fred "Pappy" Jones, seen below in 1979, built wooden rig models as a hobby and gave dozens to friends. Jones's models adorn many Michigan oil business lobbies today.

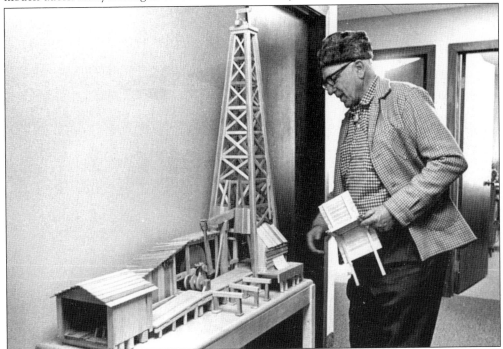

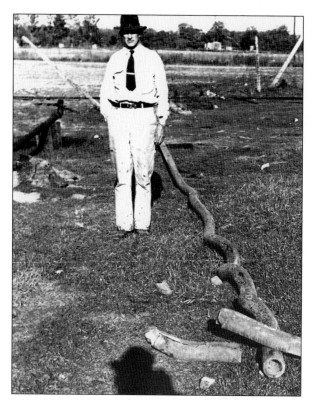

Michigan subsurface conditions are also cruel to drilling. At a 1940 Huron County well, tool pusher John Schultz posed with the corkscrewed drill pipe and broken drill bit fished from below 4,000 feet. Below, from left to right, North American Drilling president Oliver (Ollie) Irvin, welder Wayne Walker, and drilling superintendent Judson (Jud) Howdyshell look at brine corrosion of a deep hole "fish" retrieved from below 9,000 feet at the Gratiot County deep test well of 1974–1975.

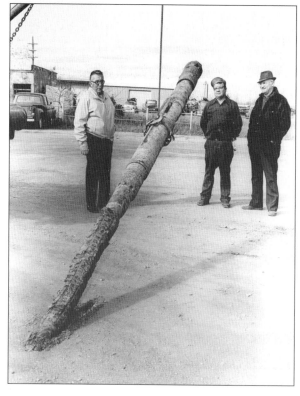

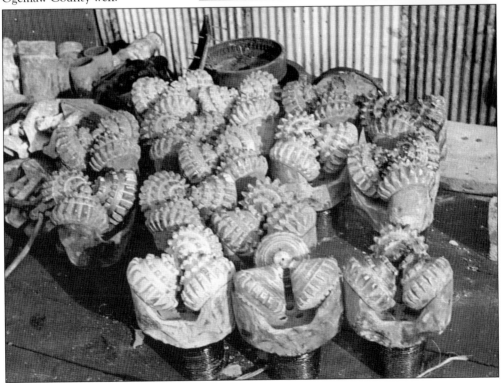

The crew on the Cryden hole of Huron County in 1940, right, show the ruined drill bit, which dropped more than 4,000 feet down the hole, corkscrewing the drill stem (previous page, top). Below, deeper wells and harder formations brought increased wear and tear on rotary drill bits, shown here in various stages of wear from being used in drilling a 1950s Ogemaw County well.

Seismic studies (energy introduced into the earth and reflections read to get a picture of subsurface geologic formations) are a staple of petroleum exploration. A 1933 seismic dynamite shoot was conducted, above, in Isabella County. Below, from left to right, William (Bill) Brown, E. A. Newman, Robert Newcombe, and Dr. Donald Barton (geophysical expert) talk after a 1938 Michigan Geological Society meeting. Barton spoke about the prospect of geophysical work coming to Michigan.

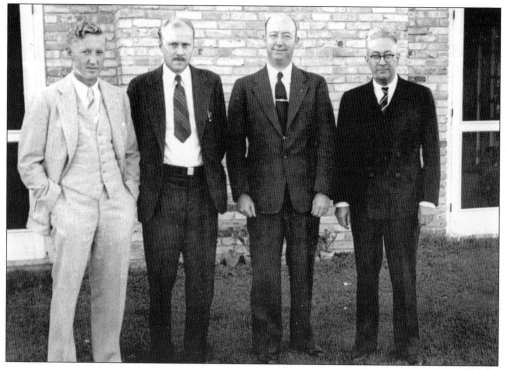

The discovery of petroleum prolific pinnacle reef oil and gas reservoirs in the Niagaran geological formation, along with the ability of geophysicists to unlock seismic data interpretation mysteries below the Dundee Formation, saw a bevy of seismic data acquisition trucks put to work in 1972. These trucks stood up on a pad and vibrated violently, sending energy bouncing off underground geologic layers to reflect back to recorders.

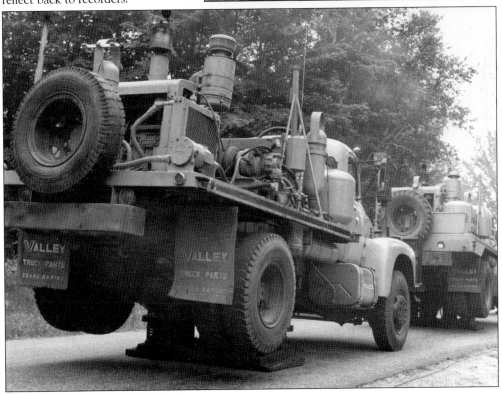

"Vibroseis" trucks worked great for seismic data acquisition where there were roads, as above in Otsego County, but more remote areas still required backpacking small explosive charges and recording devices called geophones into remote areas like the forests of Kalkaska County, below. The reflection signals, interpreted by geophysicists, gave a clue to the shape of subsurface structure that might bear oil or natural gas.

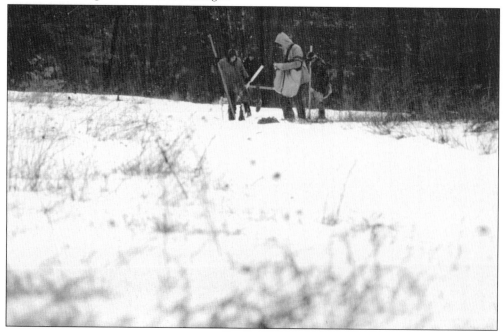

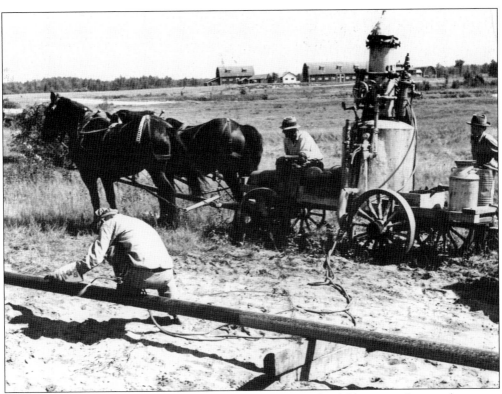

The science of laying a pipeline to carry petroleum from the field to a market pipeline or to market via a major trunk line evolved from horsed wagons equipped to supply welders with portable fuel, as seen above, in Wexford County to pipe laying apparatus that trenches and lays pipe at the same time, as seen below in Bay County.

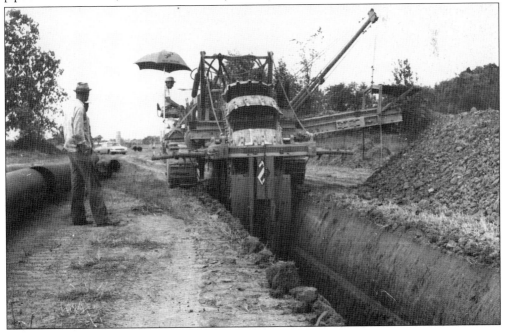

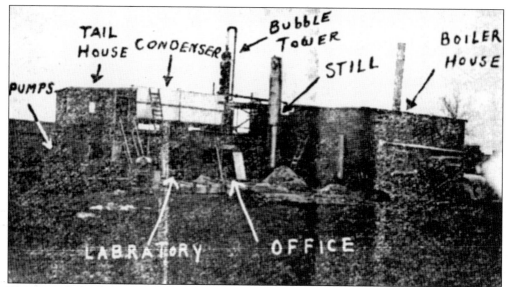

The 1934 photograph above appeared in the *Michigan Oil & Gas News* in 1934, crudely labeling the parts of the Sweet Oil Refinery built at Wyman following the Montcalm County Six Lakes Field discovery. In Mount Pleasant, Roosevelt Oil Refinery, below and on page 13, grew precipitously through the early 1950s. Note the white office building has been moved to face Pickard Street rather than backing on the railroad tracks.

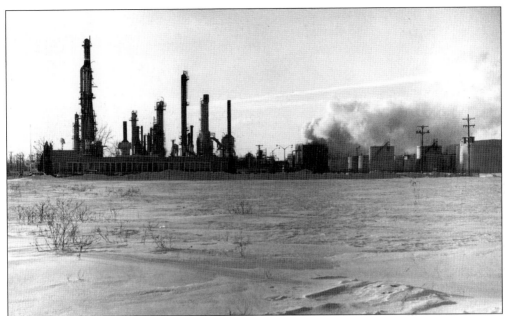

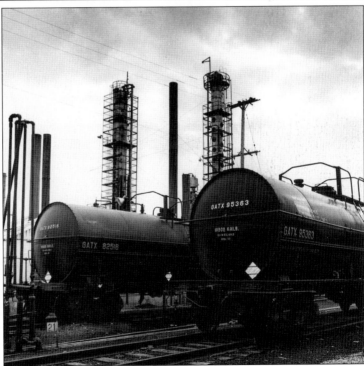

Midwest Refinery at St. Louis and Leonard Refinery at Alma merged in the late 1930s to grow as the Leonard, then Total-Leonard, and finally the Total Refinery, seen above, which operated at Alma until 2000. The short-lived Bay Refinery at Bay City, at right, was a subsidiary of Dow Chemical Company for a time, with Mount Pleasant independent oilmen Fred Turner and I. W. "Bucky" Hartman on the founding board of directors.

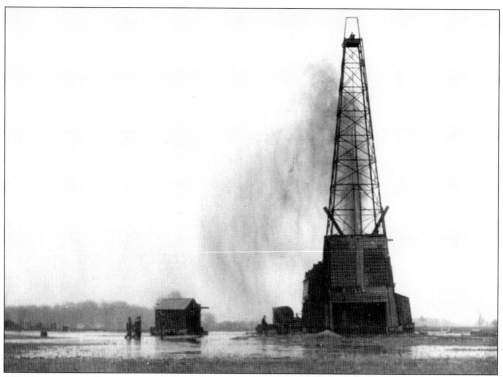

The discovery well of Arenac County's Deep River Field in 1944, above, signals the opening of the oil field that remains today as a Michigan record in terms of average recovery per acre, with more than 25,000 barrels of oil produced per acre from the reservoir underlying the perimeters of the field. The outmoded gusher well completion methods soaked countryside and workers alike, as seen below, before being replaced by advanced technologies in the 1940s.

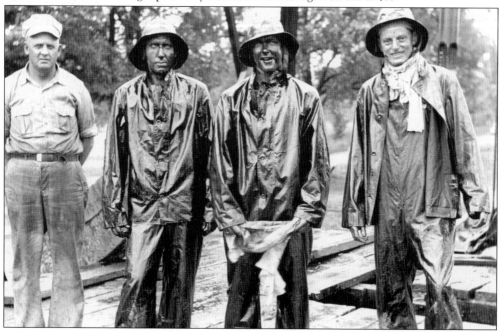

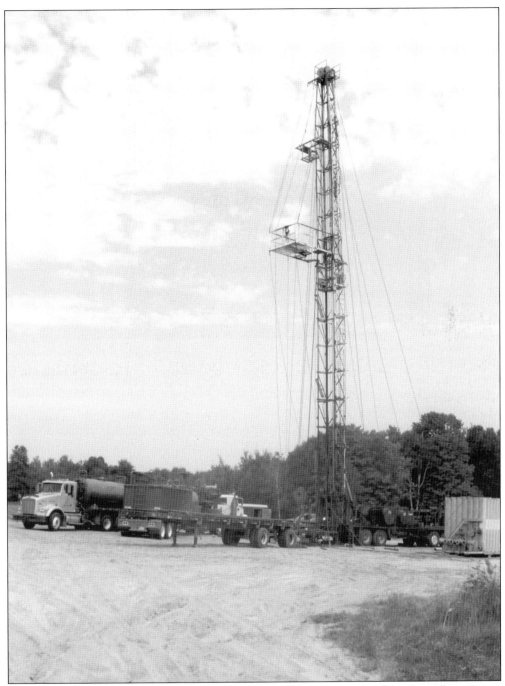

Compare this photograph of a Hillsdale County well being completed in the Albion-Scipio Trend with the spouting arrival of the Deep River Field on the facing page. Not very visually exciting, is it? A twitch on a gauge and the sudden increase in bottom hole pressure is the extent of visible spectacle of oil and natural gas well drilling success in modern times. In the mind of the public, general press, and visual media, however, the anachronism of the gusher continues to typify drilling success.

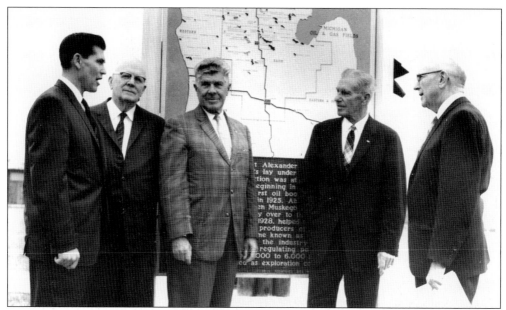

Seen above, from left to right, Alma independent oil producer explorer and MOGA president Harold McClure Jr.; Mount Pleasant resident Walter Russell; Michigan Department of Transportation commissioner M. F. Cole; association Mount Pleasant office manager Arthur Ledbeter; and Michigan historical commissioner Lewis Vander Velde, along with, from left to right below, Mount Pleasant independent oilmen I. W. "Bucky" Hartman; Robert Tope; Fred Turner; Vance Orr Sr.; and William Brown were on hand for the first Michigan historical marker dedication on southbound U.S. Route 27 (now U.S. Route 127) at Gratiot-Isabella County line in 1961.

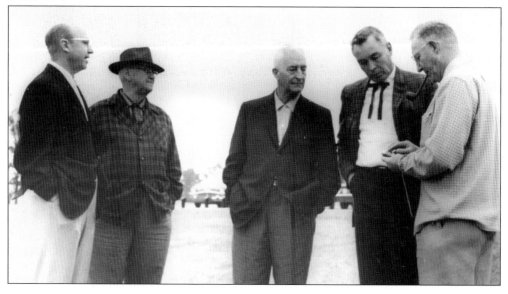

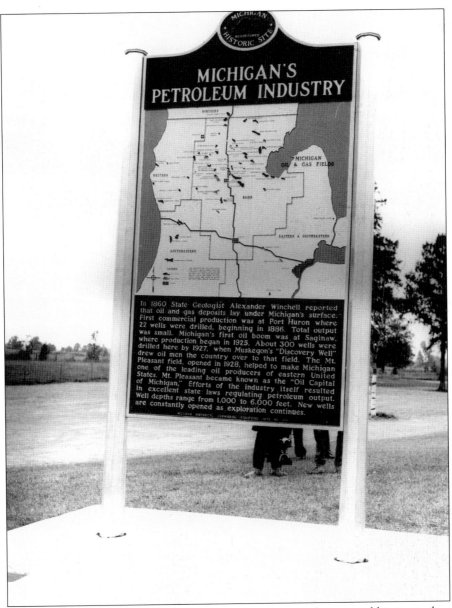

The Michigan historical marker dedicated to the petroleum industry was blown over by a late 1970s wind storm. Taken to a state warehouse in Lansing, the marker remained there until a group of oilmen found, refurbished, and reerected it in 1995. The legend reads "In 1860 State Geologist Alexander Winchell reported that oil and gas deposits lay under Michigan's surface. First commercial production was at Port Huron where 22 wells were drilled, beginning in 1886. Total output was small. Michigan's first oil boom was at Saginaw, where production began in 1925. Almost 300 wells were drilled here by 1927, when Muskegon's Discovery Well drew oil men the country over to that field. The Mt. Pleasant field, opened in 1928, helped make Michigan one of the leading oil producers of eastern United States. Mt. Pleasant became known as the 'Oil Capital of Michigan.' Efforts of the industry itself resulted in excellent state laws regulating petroleum output. Well depths range from 1,000 to 6,000 feet. New wells are constantly opened as exploration continues."

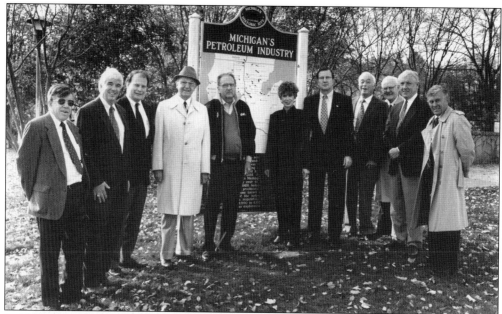

In 1995, above, the Michigan Oil and Gas Historical Marker was rededicated at Mackey Welcome Center on U.S. Route 127 near Clare by MOGA. Attending were Jack R. Westbrook, Vance Orr Jr., Gary McAleenan, I. W. "Bucky" Hartman, William C. Myler, Michigan Department of Transportation commissioner Susanne M Janis, MOGA president Frank Mortl, Vance Orr Sr., G. R. "Rollie" Denison, MOGA chairman of the board Gordon Wright, and John "Jack" Harkins.

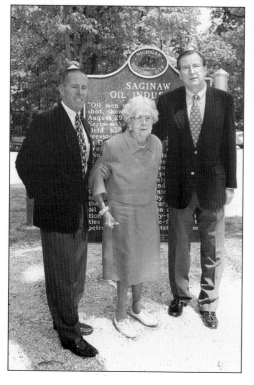

In 2001, a Michigan historical marker was dedicated at the site of the 1925 Saginaw Field discovery, seen at left, attended by MOGA chairman Michael J. Miller, Lydia Burrows (daughter-in-law of Saginaw Prospecting Company founding member George L Burrows), and MOGA president Frank Mortl.

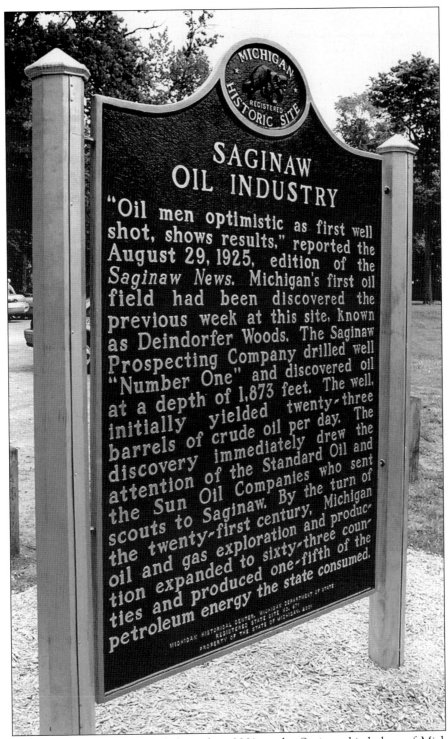

The Michigan historical marker, dedicated in 2001 to the Saginaw birthplace of Michigan's commercially producing petroleum industry, celebrated Michigan's 75th anniversary as an oil-producing state.

Unlike those in southern states, Michigan oil and gas producer and explorers face the "mud season" each spring, that time of year when the frost goes out of the ground with the advent of warmer weather, rendering lease roads difficult to navigate. The state imposes load restriction for primary and secondary roads, but equipment movement within the lease remains necessary, if challenged. At left, a dozer aids a load of cement to a drilling rig in remote Roscommon County in the 1940s. Four decades later, below, little has changed as descendants of the truck and dozer traverse a sea of Kalkaska well site mud with a storage tank.

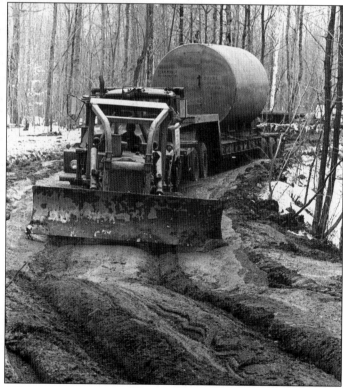

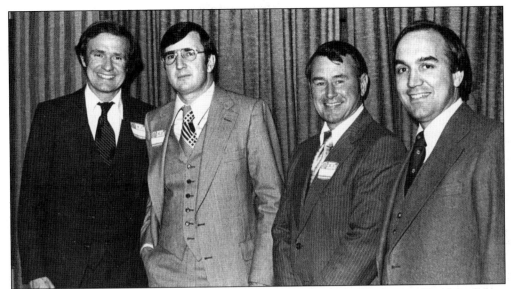

In 1977, Michigan senator Don Riegle, left, addressed MOGA and was greeted by, from left to right, MOGA executive vice president Frank Mortl, MOGA president Clyde E. "Gene" Miller, and young Mount Pleasant state representative John Engler.

In 2002, Gov. John Engler, center, held the 2002 Interstate Oil and Gas Compact Commission Chairman's Stewardship Award for Environmental Excellence, which was presented to the Michigan Natural Resources Trust Fund. From left to right are Harold (Hal) Fitch (Michigan Department of Environmental Quality chief geologist), MOGA president Frank L. Mortl, Engler, MOGA chairman Gregory (Greg) Fogle, and Michigan Department of Environmental Quality director Russell Harding.

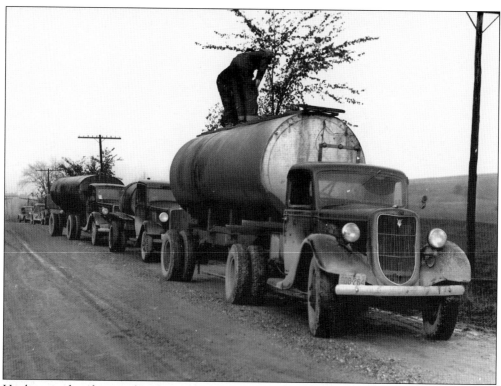

Hauling crude oil to market from remote areas not sufficiently crude oil abundant enough to warrant building a market pipeline to them has long been a Michigan oil field tradition, as above in the 1930s at Gladwin County and below in Bay County during the 1970s.

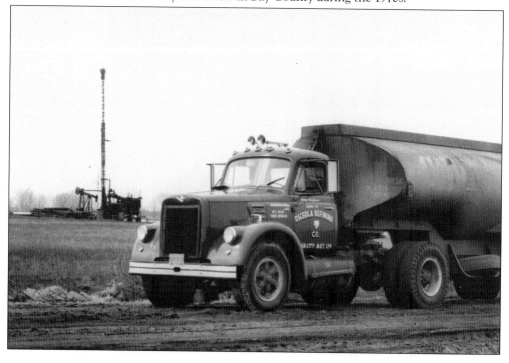

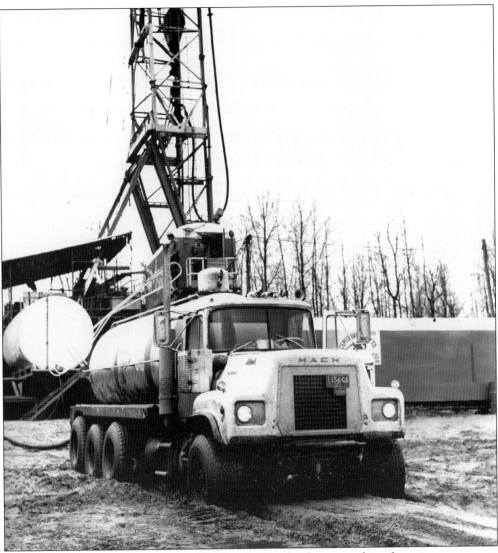

Oil field trucking touches every part of field operations, hauling everything from rig components, tanks, fresh water during drilling (above at an Eaton County drill site), cement to hold casing in the hole, drilling compounds and fluids, generators, pipe, and, ultimately, crude oil to market if the drilling venture is successful. In 1980, Dean Russell of Nelson Trucking in Mount Pleasant, an oil field trucking firm, along with James (Jim) Rainwater and other representatives from Dickinson Equipment of Mount Vernon, Illinois, (fabricators of trucks for the Michigan oil field) were chosen to go to China with International trucks built for that country's emerging petroleum exploration and production industry because the climate and field environs of the area in China where the trucks would be used so closely paralleled Michigan conditions.

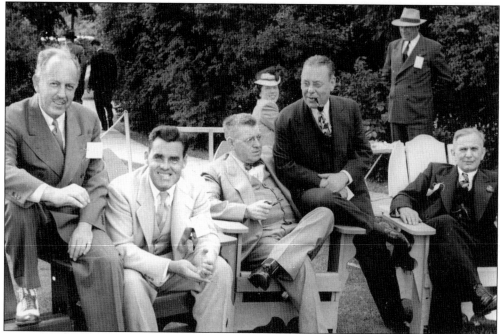

A summer tradition in the Michigan oil patch since 1939 is the MOGA Annual Picnic and Reunion Golf Outing. Modes of dress for the picnic have changed dramatically over the years. At the 1942 MOGA picnic, from left to right, MOGA executive secretary Wally Pardoe, independent producer Lee Mulver, independent Alex U. Candell, L. Wadsworth, and immediate past MOGA president George Myers look more like formal banquet than picnic attendees.

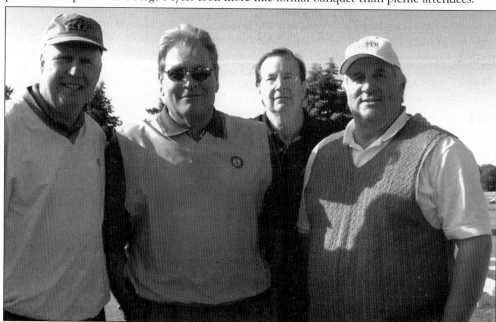

In 2005, picnic attire went more toward golf togs, as sported by, from left to right, MOGA chairman James R. Stark, Yohe Enterprise's Dan Yohe, MOGA president Frank Mortl, and Midway Supply's Richard VonReichbauer.

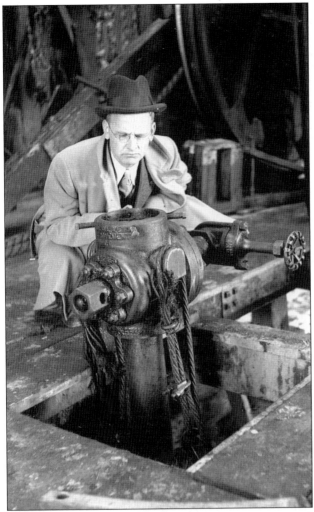

Norman X. Lyon, seen at left in 1938 and below in 1980, reported on Michigan oil and gas exploration and production activities for the *Michigan Oil & Gas News* weekly field reporting magazine for 25 years spread across 39 years before retiring in 1972. Norm came to Mount Pleasant in 1929 to "help out at the newspaper [the *Daily Times-News*] for a few weeks" and was thrust into national oil field reporting prominence by the McClanahan Struble 1 fire of 1931 (see pages 15–17). When the *Michigan Oil & Gas News* started up in 1933, Lyon began a cycle of alternating as editor of the magazine, then the newspaper, then the magazine, with forays into being chamber of commerce manager, manager of Transport Trucks (a short-lived local manufacturer), and mayor. From 1973 until his 1991 death, Lyon continued reporting for the "Oil News" as a regular, then periodic columnist. An avid photographer with a darkroom in his basement, Lyon left a legacy of some 11,000 community, family, and industry photographs, many contained in this volume.

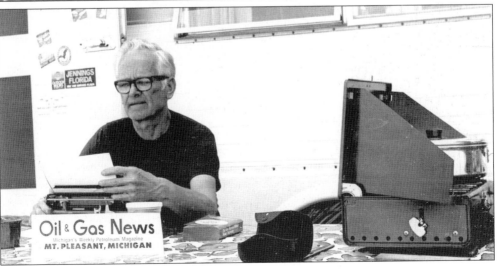

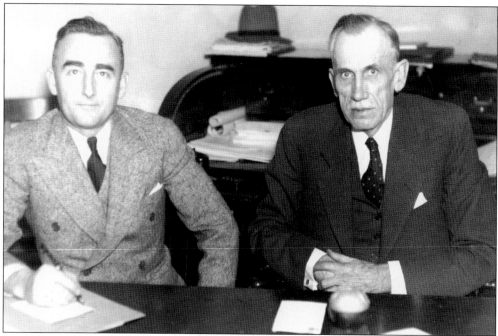

Howard Atha, right, was a founding director and first president of MOGA from its incorporation at Mount Pleasant in 1935 through 1936. MOGA was formed by oil and gas explorer and producers, refiners, pipeliners, and supportive supply and service companies to foster knowledge about and protect the interests of the industry. Atha was followed in the top elected spot by Floyd Calvert, left, who was president in 1937 and 1938.

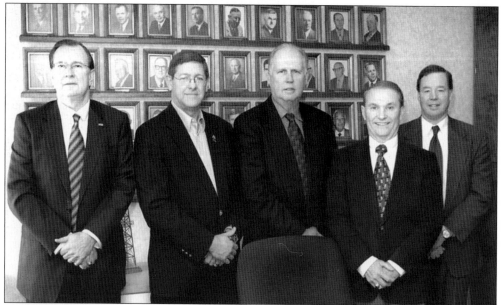

The title of the permanent chief executive of MOGA was changed in 1986 to president, with the top elected office changed to chairman of the board. The MOGA Executive Board for 2005 consisted of, from left to right, Pres. Frank L. Mortl, immediate past chairman Greg Fogle, chairman of the board James R. Stark, vice chairman Thomas H. Mall, and treasurer Richard L. Redman.

Three

PART OF THE LANDSCAPE

Working unnoticed by passing motorists, nearly hidden, and dwarfed by the vastness of the northern Michigan forest, a rotary drilling rig in Otsego County drills toward Niagaran Formation along the northern pinnacle reef trend in search of the oil and gas at depths of 5,000 to 7,000 feet in the northern Lower Peninsula or 3,500 to 5,500 feet in the southern part of the state. Niagaran pinnacle reefs are the denser rock-encased remains of ancient coral reefs harking to the days when what is now Michigan was a tropical sea near the equator in early geologic times. Now the machinery of oil and gas exploration is woven into the tapestry of natural and human activity to help feed the state's voracious appetite for oil and gas through orderly development of the abundant underground natural resources.

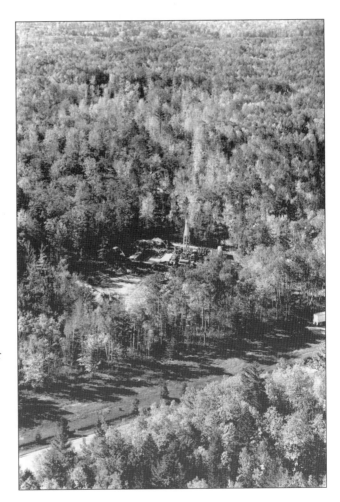

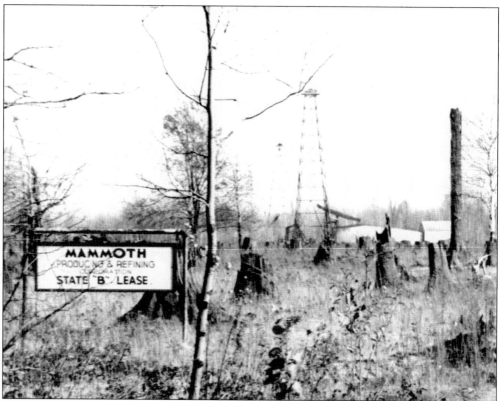

After 1939, oil and gas development saw minimum well spacing of 10 acres. Prior to the 1939 passage of Michigan Act 61, there was no required well spacing and "closeology" was the norm. Fields in Clare County, above, and Kent County, below, illustrate the need for 10-acre spacing, fields were crowded. Today wells are spaced as little as one well per 80-acres up to as much as one well per 640 acres, depending on depth to be drilled.

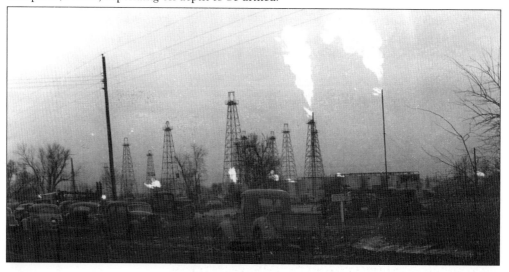

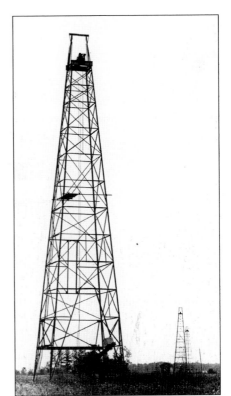

Permanent derricks of Midland County's Porter-Jasper Field, discovered in 1933, bear witness in the 1970s, as seen at right, to the 555 wells drilled there—some continue to produce small amounts of oil. Clare County's Winterfield Township oil wells, which from shallow traverse and Dundee formations at 3,100 and 3,700 feet in the 1940s, below, are joined by a 1988 well drilled to deeper zones to become a natural gas discovery.

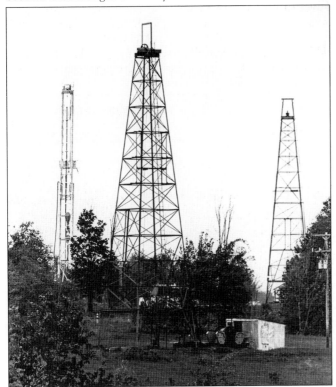

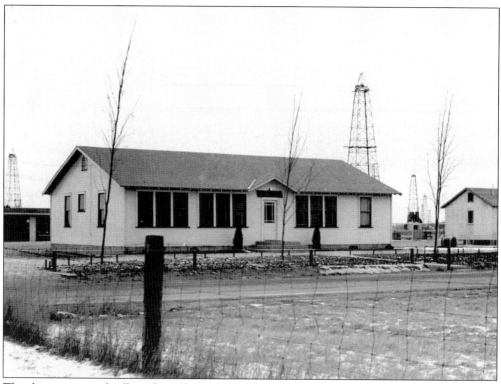

The closer spacing of wells in the early days and wider spacing of modern times are demonstrated by the above Mount Pleasant Field photograph and the remotely located well being drilled in Mason County in the 1980s. Improved technology and a desire for conservation of the resource reduced the number of wells that needed to be drilled to adequately "drain" the oil or gas reservoir.

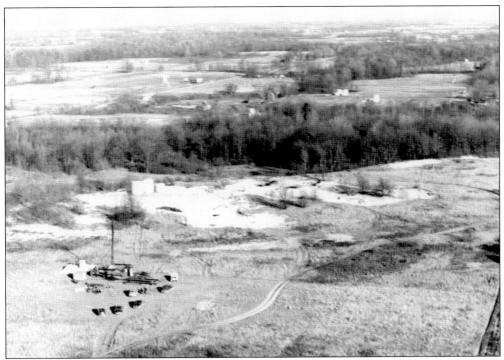

Montcalm County's Reynolds Field, seen here from the air, was discovered in 1954 by Swan-King, Basin Oil Company, and Alma's McClure Oil Company. A cable tool rig, above, drills to the Detroit River Formation, Reed City section at about 3,500 feet. Just down the road, a pumping unit and tank batteries are surrounded by dikes to protect the surrounding lands from rare spills or unexpected leaks.

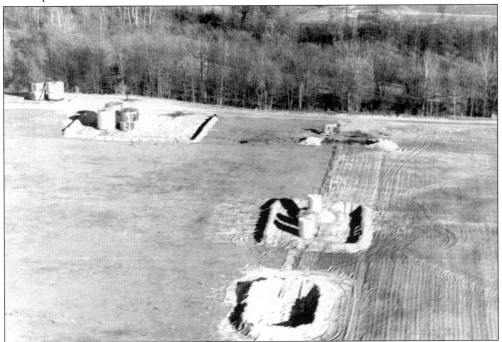

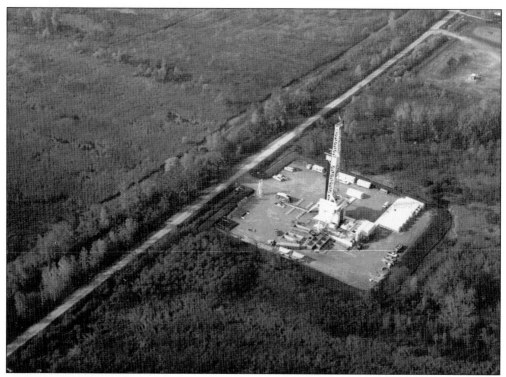

From the air, more modern oil and gas drilling operations show clearly defined drilling unit pads occupying minimal space, as seen above in Manistee County. Michigan's first "horizontal drain hole" was drilled in 1984 by PetroStar Energy and Terra Energy Limited. Operators drilled a 400 foot horizontal hole from the vertical well bore at a point some 6,000 feet below the surface in order to enhance production from a low permeability Niagaran well.

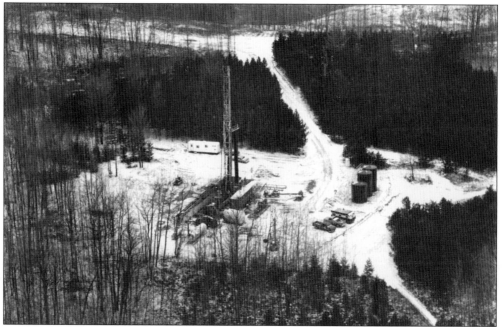

The two "near water" photographs on this page, on the right in Kent County and below in Ottawa County, might well be labeled "stuff that is not done any more." Environmental concerns by both industry and citizenry have seen modern requirements of minimum setbacks of drilling rigs from water's edge. Directional and horizontal drilling techniques, used by the industry since the early 1970s, have rendered drilling rig placement so close to the water unnecessary.

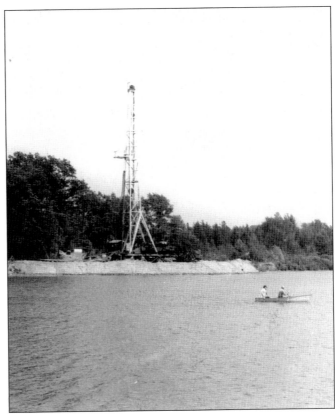

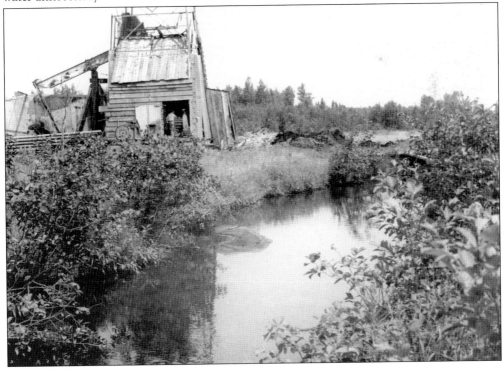

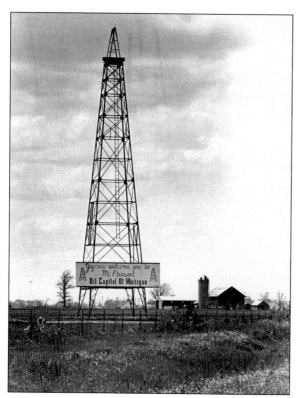

Evidence of the close meld of the oil and gas industry and the central Michigan city of Mount Pleasant are found in the sign erected on a steel derrick in the mid-1970s south of town on northbound U.S. Route 27, at left, and proximity of Lease Management Company's yard and warehouse, below, where the city water tower serves as backdrop to the mast of a well service rig being inspected.

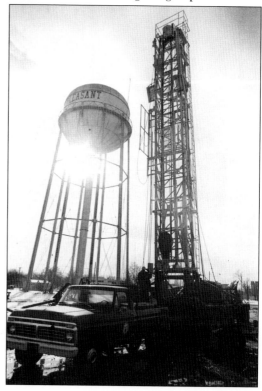

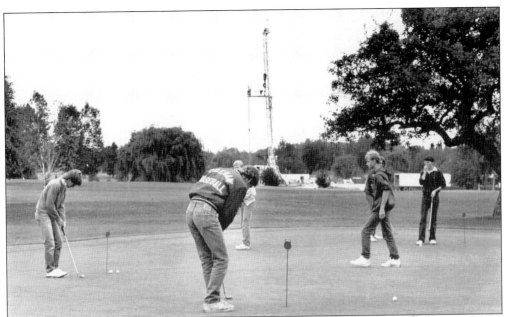

Drilling rig presence was par for the course and part of the West Branch Field play that includes the West Branch Country Club. For decades the Country Club benefited from oil production beneath its land, given a new lease on life by this Marathon Oil Company secondary recovery work over in 1985.

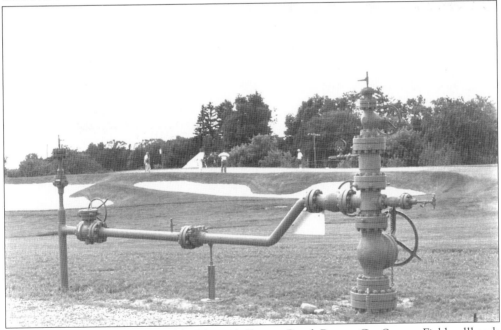

In southeastern Michigan, one of the Macomb County South Romeo Gas Storage Field wellheads serves as a frame for golfers on the Hole No. 1 green at the Orchards, a golf course built in 1993 over the storage field by a partnership that included MCN Corporation, Michigan Consolidated Gas Company's parent company. From the course, golfers can see the downtown Detroit skyline, 29 miles away.

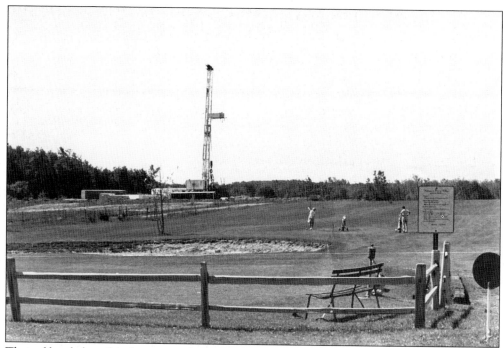

The golf and the oil industry got along just fine in 1985 in Ingham County, where Northern Michigan Exploration Company drilled a Vevay Township Niagaran well just a dogleg left of Hole No. 10 at the Mason Golf Club. In Newaygo County's Woodville Field, Grand Rapids independent Wolverine Gas and Oil Company drilled this deep gas well before the summer of 1986 ended, because of the well's proximity to Pine View School.

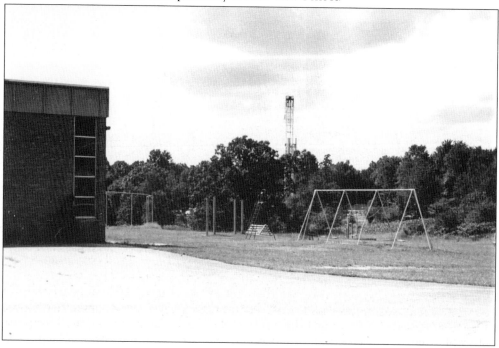

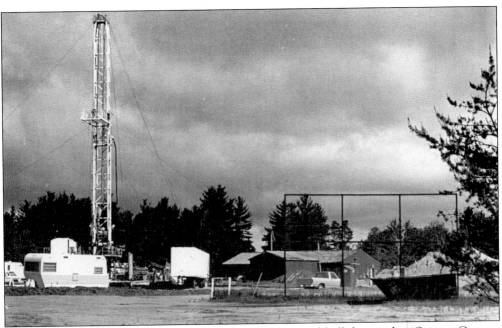

This drilling rig brought a whole new ball game, an unused ball diamond in Oceana County, hitting a petroleum home run 5,600 feet beneath the athletic field to score one for the oil and gas explorers. On average only 1 in 10 wells drilled finds oil or natural gas, in field development wells. Wildcat, or exploratory wells, have a 1 in 50 chance of discovering a new field.

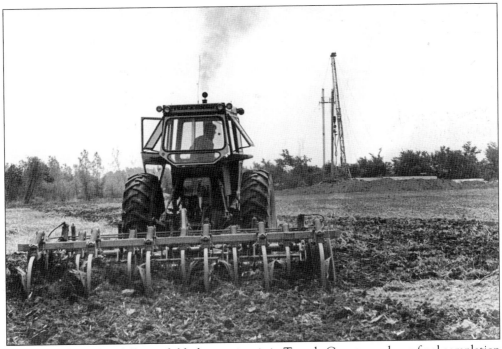

Playing an altogether different field, this service rig in Tuscola County works on final completion of a well to refresh the hole's crude oil production ability on the same acreage being retreated to prepare for seeding a new crop atop the land.

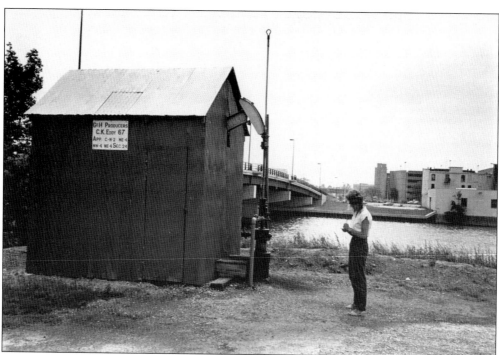

Oil and gas exploration and production occurs alongside both city and country life, as shown above in 1986, where Michigan Geological Survey geologist Jean Shoquist inspects performance of an original Saginaw Field well, still operating since the 1920s just across the Saginaw River from downtown. Below, a drilling rig shares a field under till on a Gladwin County farm in the 1970s.

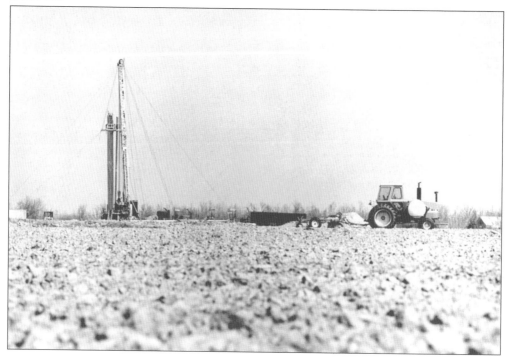

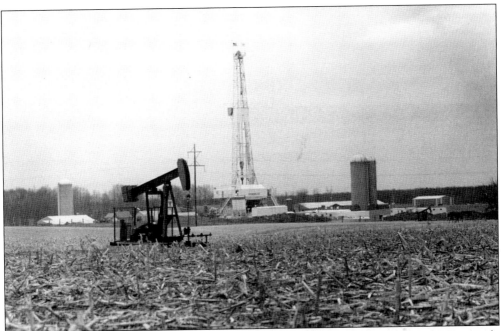

In 1986, above, a rig drills for Amoco Petroleum and Marathon Petroleum to the Prairie du Chien formation at 12,000 feet at West Branch Township of Ogemaw County, the derrick towering above the farm buildings and a pumping unit dating to the 1952 West Branch Field, still producing oil from the Deep River and Richfield formations.

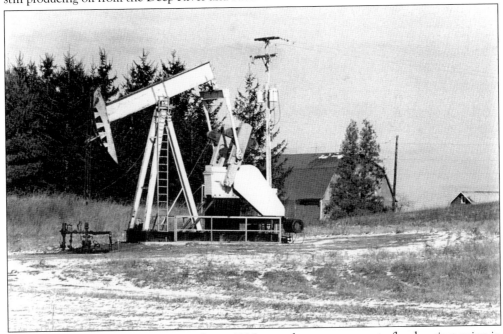

In the south, Mobil Oil Corporation has a 1986 secondary recovery waterflood project going in the Ingham 13-2N-1E Niagaran reservoir, where three producing wells are served by two water wells. Ingham County pumping units were a common sight after Mobil opened the southern Niagaran reef trend in the 1970s.

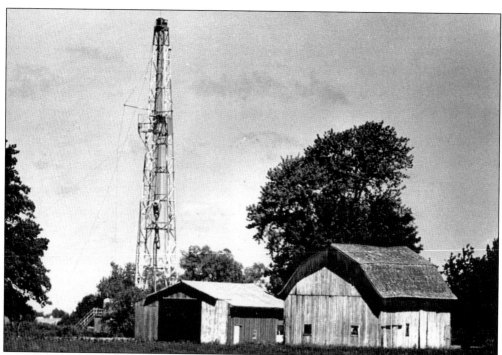

Petroleum explorer/producers try as much as possible to use road infrastructures already in place on the farm to reach the drilling and, hopefully, production site. In the summer of 1974, above, McClure Oil Company began drilling Michigan's record depth well, a dry hole, to 17,468 feet. A deep test well with the derrick full of pipe, below, changes drill bits in the bitter Missaukee County winter.

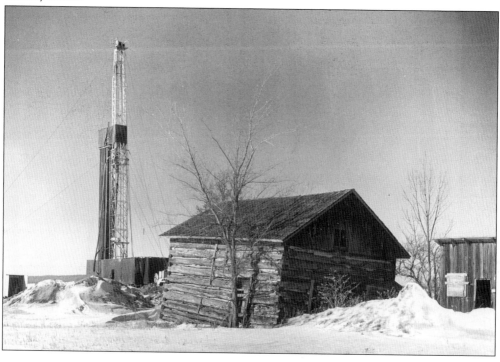

Historically drilling "out behind the barn" is frequent practice in Michigan in order to minimize surface disturbance by using existing farm road access to the site. At right, a Gratiot County steel derrick from the 1940s continues to work beside the silo while, below, a drilling rig makes a temporary barnyard appearance in Eaton County. The rig is replaced by a wellhead or pumping unit if drilling is successful.

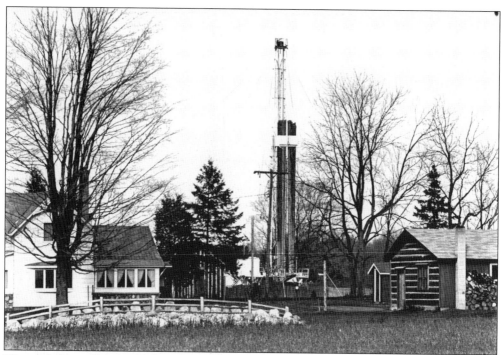

"Come drill a well in my backyard" is often heard from those who believe oil or gas lies under their land. If that possibility exists, the explorer will find them to lease the right to drill. While it may appear the folks in Mason County, above, and in Eaton Rapids, below, have taken the "drill in my back yard" literally, the size of the rigs make them appear nearer to the homes than the actual hundreds of feet distance.

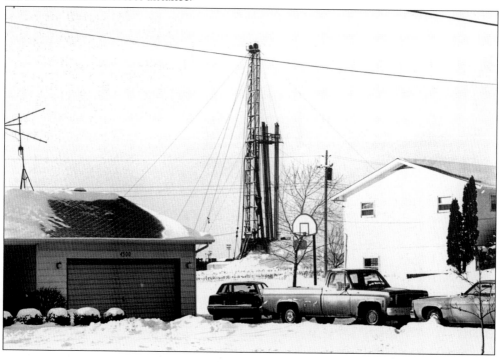

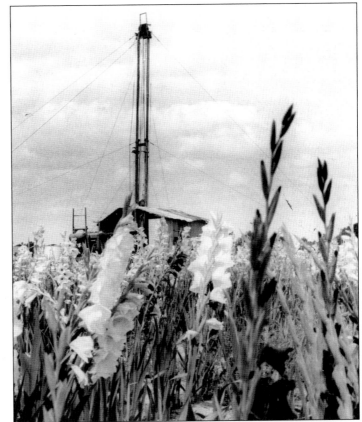

From the flowered fields of Allegan County, at right, to the Christmas tree farms of Wexford County, since 1925 Michigan oil and natural gas exploration has taken place in all Michigan Lower Peninsula counties, resulting in production from 64 of the 68 counties there. In the Upper Peninsula, 29 attempts to find producible oil or gas to date have failed.

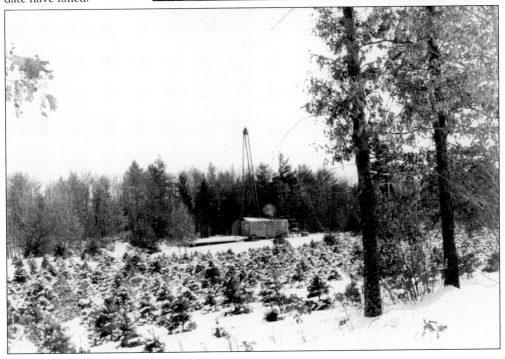

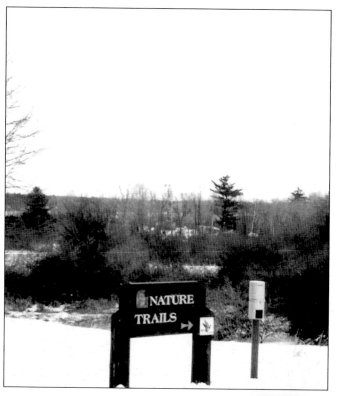

The drilling process, involving a tall rig and lots of equipment movement, can sometimes be disturbing to some who think that temporary spurt of apparently frantic activity is a permanent fixture along their favorite nature trail, at left in Manistee County, or woodland path, and below in Montmorency County. Regulations restrict noise around petroleum production facilities and a few weeks after the well is drilled, most people forget it is there.

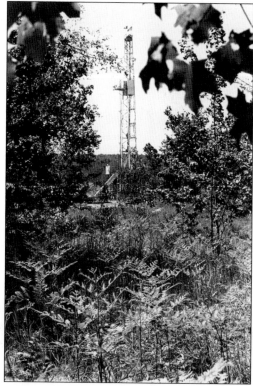

Framed by pond reeds in Sherman Township of Osceola County, at right, this deep rig reached a total depth of 11,929 feet on a 1986 deeper pool test within the perimeters of the Mineral Springs Dundee formation field, discovered in 1951 at 3,854 feet. Wells to deeper zones often discover new petroleum reserves beneath proven shallower reservoirs. Below, a Northern Michigan Exploration Company 1983 well is drilled to the Niagaran formation in Presque Isle County.

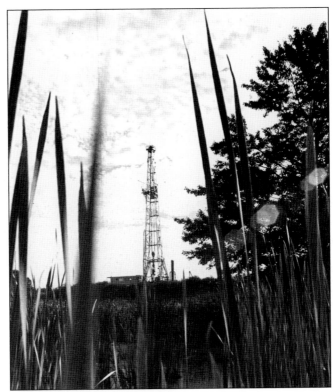

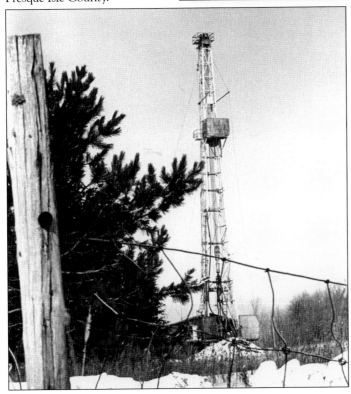

Travelers on Interstate Freeway 75 north of Bay City, at left, got an up close and personal glimpse of drilling operations when this deep gas well was drilled by Shell Oil Company. Companies often drill close to highways, to minimize surface upheaval by utilizing existing roads. The St. Clair County well site near the town of Memphis, below, fit right in with the other commercial activities along highway M-19.

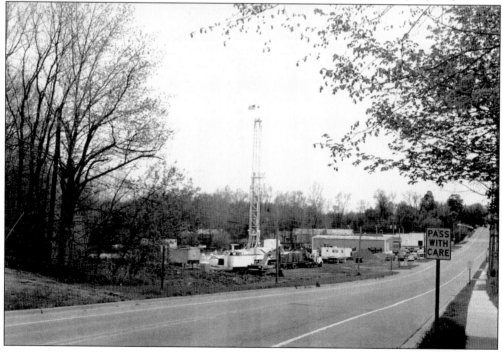

Fourth of July weekend motorists zip by a
Burleigh Township of Iosco County drill site
along State Route M-65, above, and beside
Seventeen Mile Road in Calhoun County, at
right. Oil and gas operations along highways
draw stares when passersby encounter a
drilling rig, a sight along their Michigan
roadside they probably thought was more likely
to be seen in the southwestern United States,
where, in the more widely known oil states,
drilling rig encounters are more common.

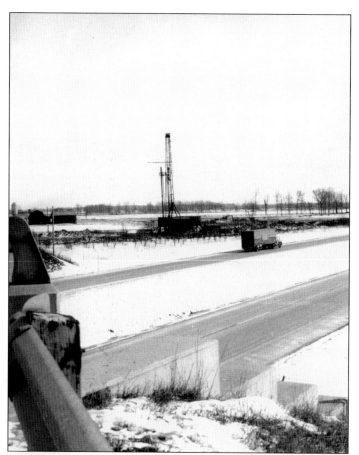

Wintry Ogemaw County, along Interstate Freeway 75, serves as the foreground for a drilling rig, at left. Later in the year, beside State Route M-65 in Ogemaw County, below, the summer of 1987 sees a drilling rig crown block looming above the treetops, serving as a reminder that the search for oil and gas in Michigan is a four season operation. Remote locations and long hours give rise to the saying "once the rigs were wooden and the oilmen were made of iron, now both are of tempered steel."

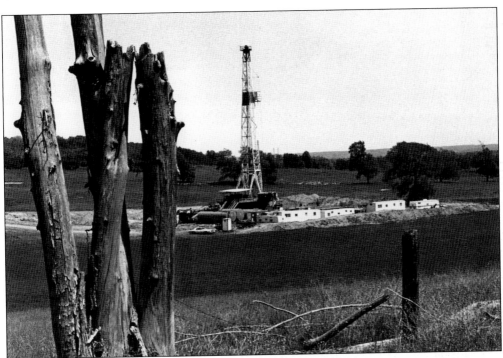

Man's oldest light and heat source, wood, serves as the foreground for these drilling scenes in Goodwell Township of Newaygo County in summer, above, and Osceola County in winter, at right. Michigan production was predominantly oil for many decades. Recent years have seen natural gas represent the lion's share of Michigan production, first as a function of the Niagaran pinnacle reef trend of the 1970s, then the deep gas play of the 1980s, and now the recent shallow Antrim Shale formation gas play.

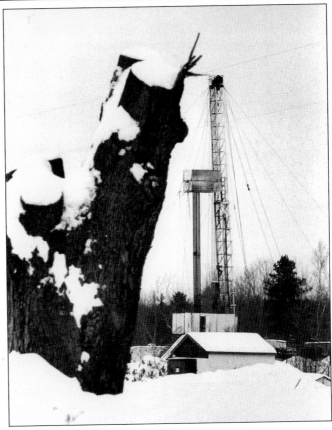

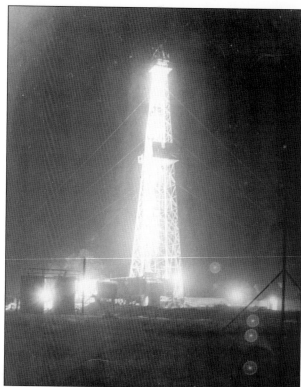

Gulf Oil's Bateson well in Bay County set a new state drilling depth record of 9,000 feet in 1940 and lit up the night sky, attracting sightseers for months. Reaching the salina strata, the well produced about 50,000 cubic feet of natural gas per day before bursting into flame on December 5, 1940. The rig became twisted rubble in a short time, but the site was rebuilt and the well produced again.

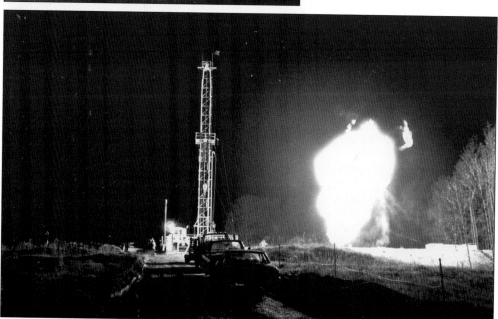

Lighting up the sky in a different manner, the Jennings Petroleum Corporation Anderson 1-8A discovery well in Newaygo County flare tested at rates up to 10 million cubic feet of natural gas per day from nearly 8,000 feet deep in the Prairie du Chien formation and also discovered petroleum in the middle Silurian age Clinton formation in 1983. The well was the first directionally drilled Michigan Central Basin deep test.

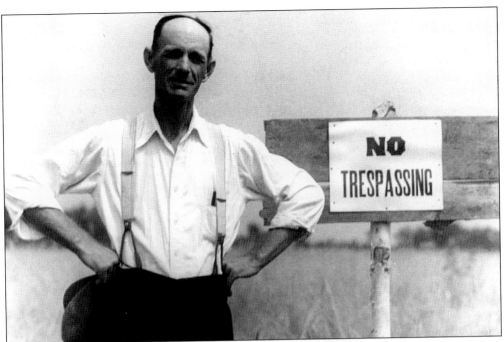

Occasionally a landowner, like the one above in Arenac County with an issue in 1941, can be aggressive in their objections to the presence of oil and gas activity, particularly if they do not own their mineral rights. Sometime folks just want to keep things to themselves. Other times, as seen at right at a Sun Exploration and Production Charlevoix County site, operators are equally adamant about keeping visitors away, especially when protecting proprietary information during drilling, and declare their hole a "tite hole," meaning everybody should stay away. In Michigan, the state requires the release of confidential drilling data, six months from well completion.

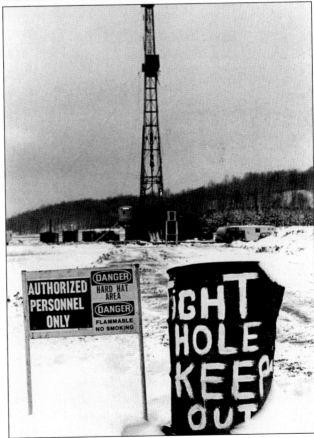

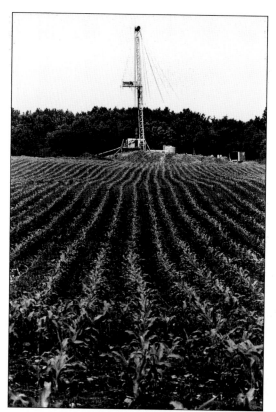

Sharing the surface with cash crops above the ground, drilling rigs seek a payoff for the explorer/producer and the land and mineral owner deep below the roots of corn in Isabella County, seen at left, and in a Van Buren County orchard, below. Mineral owners receive an advance per acre bonus upon signing a lease granting drilling rights to a company and a percentage of the petroleum production resulting from drilling.

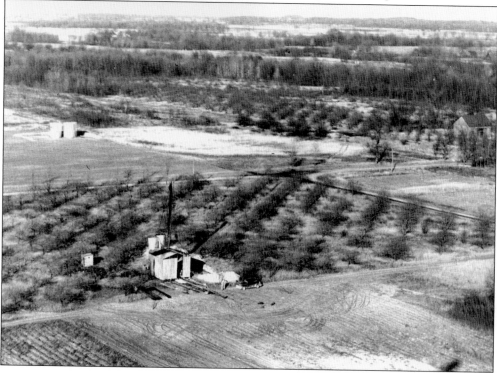

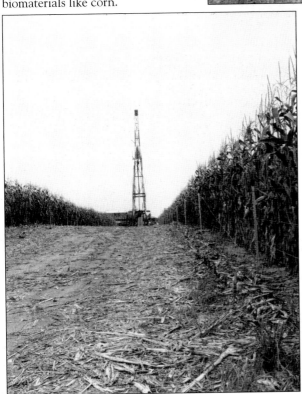

Most drilling is done in rural areas, where large tracts can be leased from a small number of landowners. At right in 1943, a cable tool rig works in a Gratiot County cornfield, and below, a more modern 1990s rotary rig grinds through Jackson County soil. The symbiosis of corn and petroleum grows in the early 2000s as gasoline retailers increasingly stock ethanol blends, which depend heavily of biomaterials like corn.

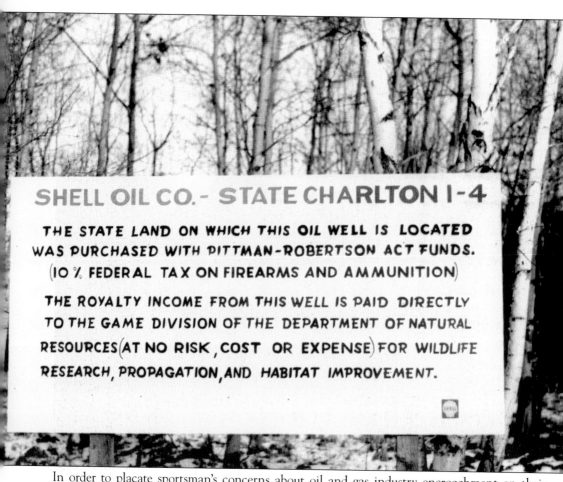

SHELL OIL CO. - STATE CHARLTON 1-4

THE STATE LAND ON WHICH THIS OIL WELL IS LOCATED WAS PURCHASED WITH PITTMAN-ROBERTSON ACT FUNDS. (10% FEDERAL TAX ON FIREARMS AND AMMUNITION)

THE ROYALTY INCOME FROM THIS WELL IS PAID DIRECTLY TO THE GAME DIVISION OF THE DEPARTMENT OF NATURAL RESOURCES(AT NO RISK, COST OR EXPENSE) FOR WILDLIFE RESEARCH, PROPAGATION, AND HABITAT IMPROVEMENT.

In order to placate sportsman's concerns about oil and gas industry encroachment on their province, this sign appeared on a 1970 Shell Oil Company well in Charlton Township of Otsego County.

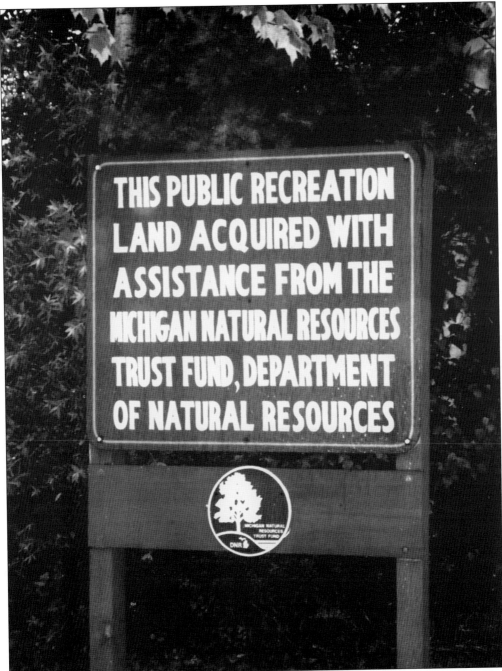

Signs like this one on Burt Lake in Cheboygan County began springing up throughout Michigan following the 1976 establishment of the Michigan Natural Resources Trust Fund, which uses revenues from oil and gas activities on state-owned mineral properties. Since 1976 through 2005, the Michigan Natural Resources Trust Fund Board has approved 1,439 public recreation land acquisition and development projects (parks, rail-trails, beaches, and more) totaling $672,400,200 through 2005.

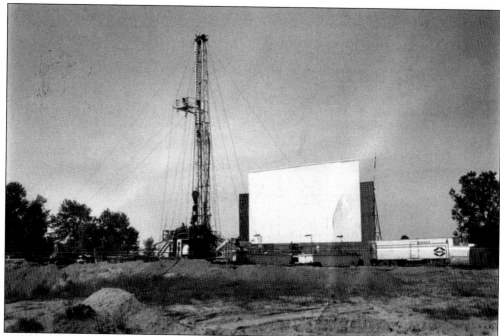

A new feature at the defunct Northland Drive In Theater north of Rosebush in Isabella County, above, was McLachlan Rig 1, drilling for the Mount Pleasant-based Summit Petroleum Corporation in the old Vernon Field, targeted to the Dundee geological formation. A crude oil pipeline, below, is constructed after passing underneath a Crawford County highway using a horizontal drilling technique later adapted to oil and gas drilling.

A 1930s drill-in at a Clare County well location drew a crowd of interested parties and sightseers, above. When the Albion-Scipio Trend was developed in southwestern Michigan during the 1950s and 1960s, communications were better and successful well completions were more common so that drill-ins attracted smaller audiences. In the oil field of today, data transmission has improved so much that usually the only people on hand during drill-in are the drilling crew.

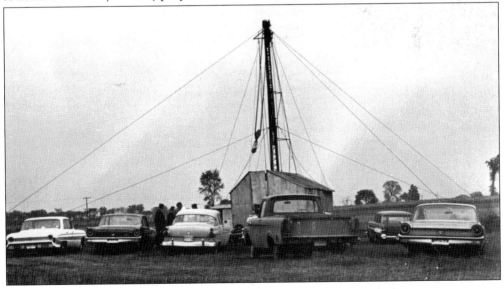

CH&P Drilling Company Rig 2 sits on a hilltop just east of Gaylord in Livingston Township of Otsego County, above. It is drilling an Antrim Shale Formation well in a shallow play that has kept the Michigan industry busy for close to two decades. Drilling a Niagaran formation southern Michigan pinnacle reef try in tight drill pad quarters, Don Scott's rig is nearly hidden by the surrounding Oakland County woodlands.

Four

ANIMAL INTEREST

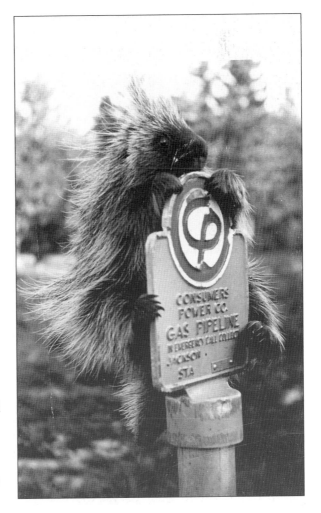

Concern for the protection of animals in the near proximity of petroleum operations is often a topic in some facets of society. Concern for the equipment of the industry in the near proximity of animals, however, is seldom addressed. In 1973, Consumers Power Company, one of the companies operating gas transmission lines in northern lower Michigan, said that varmints, particularly porcupines, had developed a taste for their aluminum pipeline markers as teeth-sharpening devices. The company was forced to install "unclimbable posts" along almost 200 miles of pipeline at an undisclosed but doubtless exorbitant cost.

Charlie the Raccoon, at left, was a regular visitor to Provins Rig 5 at a Clam Union Township, Missaukee County, site in 1981. Charlie tried to convince Page Petroleum's Ray Sinkbeil that he was handout worthy. Not quite as sociable but equally on the lookout for handout, voluntary or otherwise, an unnamed opossum slips through the fence near a 1961 Lenawee County drilling location.

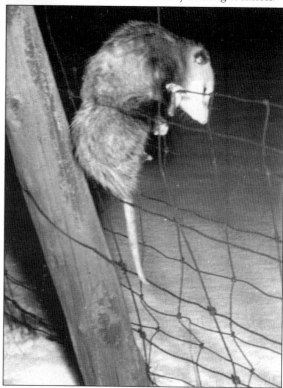

Missaukee County horses watch with interest and nonchalance, at right, as a well is drilled beyond their corral; one looks on hopefully, as if the energy from the well will someday lighten his load, while the other is more interested in the hay before him. A pair of watchdog German shepherds, below, guard a 1943 Arenac County production facility in an age when World War II brought about vigilance against sabotage.

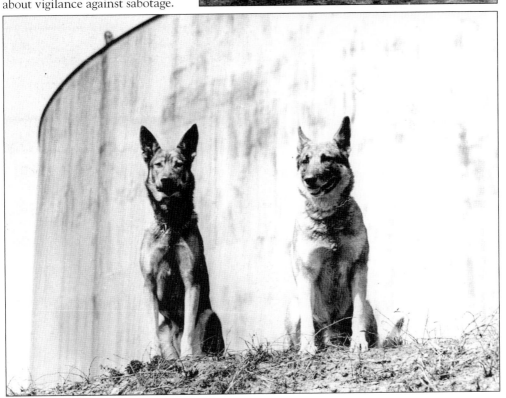

A not-quite-so-vigilant farm dog, above, curiously observes the start of construction of a derrick platform in 1940s Midland County. C. K. "Curley" Dean, below on the left, shows off his unnamed pup to T. F. "Mack" McQuaid at an offset well in the South Buckeye Field of Gladwin County in 1961.

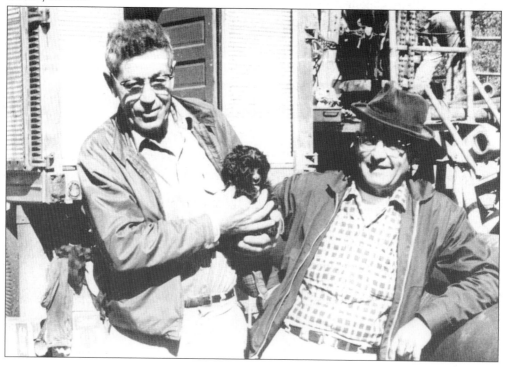

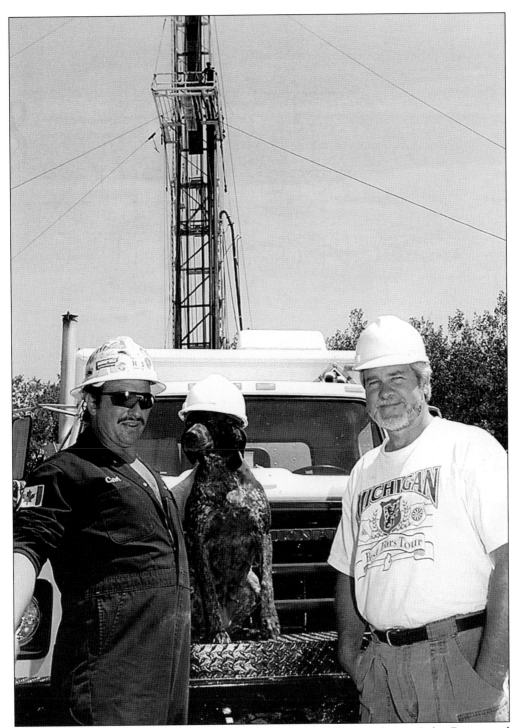

From left to right, driller Carl Jock, German shorthair pointer Rosie, and Great Lakes Directional Drilling's John Gordon, all wore hard hats at Consumer's Power Cranberry Lake C-990 well in Winterfield Township of Clare County in 1999.

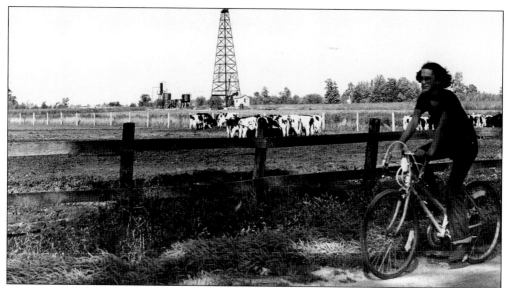

The bovine population and the bicyclist in Mecosta County, above, paid little attention to the oil well part of their environment. Cattle near the Grand Traverse County Niagaran well being drilled for Traverse City's Mack Oil, below, were more interested in the cameraman than the drilling operations behind them.

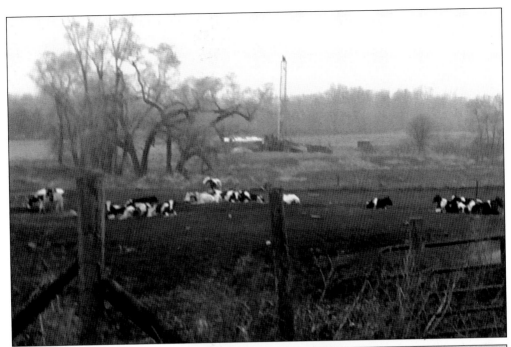

The cows at a Mecosta County well site, above, were not particularly interested in anything. Folklore has it that when cows lay down, it is going to rain. They were misinformed or not aware of the folklore—it did not rain that day. A little further north in Oceana County near Pentwater, at right, these "moo-dy" prognosticators were undecided about the weather and totally oblivious of the drilling operation going on in their feed lot.

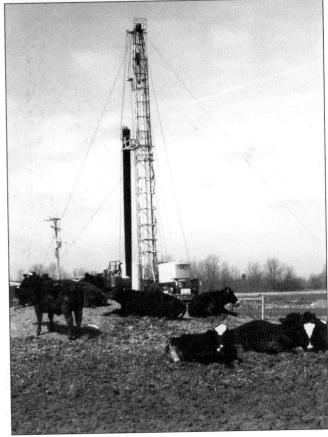

Gaylord's Elk View Park, a Michigan Natural Resources Trust Fund–aided project, is classic irony; concern for the elk was part of the controversy settled by creation of the fund, which helped finance the park where elk live with natural gas wells. An elk calf, above, stands near a working gas well in the park. Up the hill from the well, below, adult elk graze unconcerned with people or the well.

Five

AN ENERGETIC GROUP

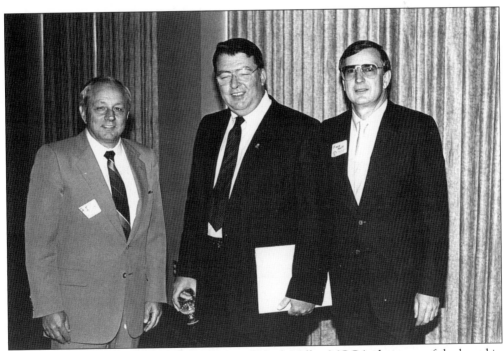

Seen here, from left to right, is a historic trio: H. Jack Miller, MOGA chairman of the board in 1988 and 1989, was the third Miller brother to serve in the highest elected executive association office (C. John in 1966–1967, Clyde E. "Gene" in 1976–1977); Tom Washington, president of the Michigan United Conservation Clubs; and Frank L. Mortl, MOGA president, the longest serving permanent chief executive officer in association history. Together Mortl and Washington, in 1975, were prime movers in the creation of the Michigan Natural Resources Trust Fund, a unique partnership of industry and government that was the first of it's kind in the nation dedicated to the acquisition and improvement of public recreation lands.

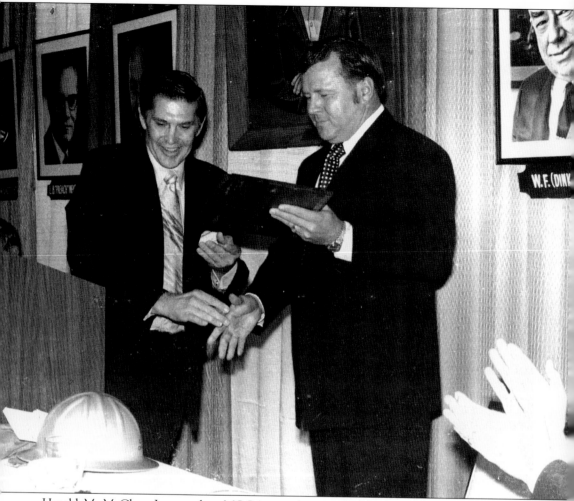

Harold M. McClure Jr. served as MOGA president in 1961 and 1962, was elected the first Michigan president of the national Independent Petroleum Association of America in 1968, and drilled deep exploratory holes on Beaver Island in 1961 and at Ithaca in 1975, retrieving vital deep Michigan geologic strata information later used as a blueprint for the Central Basin deep play of the 1980s. C. John Miller, who parlayed drilling rigs acquired from his father into a leading oil and gas exploration and production company, was elected MOGA president in 1966 and 1967, was elected second and (last to date from Michigan) president of the Independent Petroleum Association in 1973 and 1974. Miller was later appointed permanent president and chief executive officer of that organization when the elected top office title was changed to chairman of the board, and was named one of the 100 most influential people in the petroleum industry of the 20th century in 1999.

Mount Pleasant oil and gas explorer/producer D. F. Jones, seen at right, celebrated the completion of his discovery well in 1937 in Buckeye Township of Gladwin County with a burst of enthusiasm. Equally exuberant when informed that Michigan Act 61, Michigan's Oil and Gas Law, was passed by the state legislature into law in 1939 was Rex Oil's Harold M. McClure Sr., of Alma, third MOGA president.

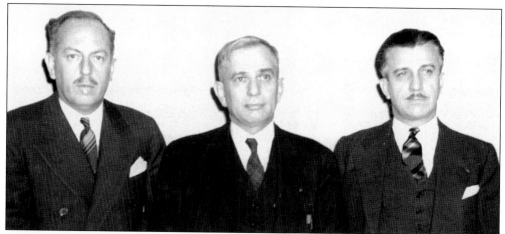

Wallie Pardoe, MOGA's second permanent chief executive from 1941 though 1945, is seen on the left with 1941 association president George W. Meyers of Sun Oil Company (center) and Kurt H. deCousser of Socony-Vacuum (forerunner of Mobil Oil Company) who was MOGA president during 1942 and 1943.

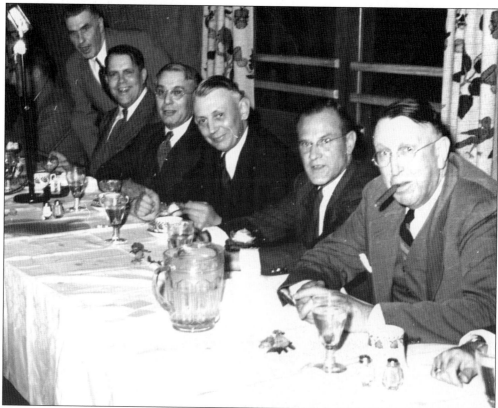

Shown here at a 1941 banquet, from left to right, the World War II MOGA leadership includes: Art Ledbeder, Mount Pleasant MOGA office manager; Harold McClure Sr.; George W. Meyers; Col. Harold B. Fell, Petroleum Administration for War Committee chairman; Chuck Smith, MOGA treasurer; and Basin Oil Company president James Graves, MOGA president from 1944 through 1945.

The Michigan Conservation Department Geological Survey Division Mount Pleasant Field office staff includes, from left to right, field geologists Tom Knapp, Jack Rulison, William Daoust, Lyle "Pic" Price, and Glenn Sleight, seen above. They are at the 1937 Oil and Gas Exposition at Island Park in Mount Pleasant. Present for a 1938 Geneva Township, Midland County, Sun Oil Company wildcat drill-in, below, from left to right, are Samuel Burman, Howard Pew, Russell Belfield, Glenn Sleight, Frank Larimer, Noah Andrews, and C. M. "Click" Wanbaugh, who started Sun Oil Company in 1893.

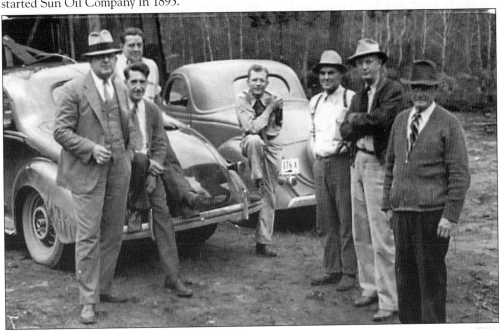

Independent Petroleum Association of America executive secretary Col. Howard B. Fell, second from the right above, was the speaker at a 1946 MOGA banquet. He is sharing the head table with past and future MOGA presidents, from left to right, Floyd Calvert (1937–1938), C. W. Teater (1947), Harold McClure Sr. (1939–1940), W. P. Clarke (1946), George Talbot (1948), and James C. Foster (1949–1950).

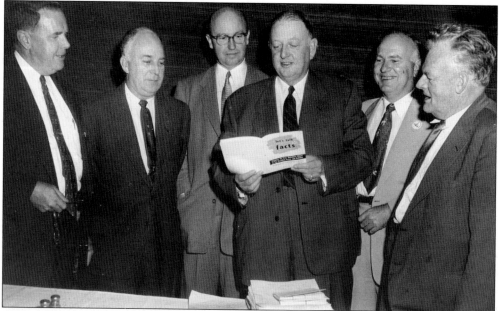

William Palmer, a former state senator who served as MOGA executive secretary from 1949 through 1970, and past and future MOGA presidents E. Allan Morrow (1957–1958), I. W. Hartman (1951), J. Walter Leonard (1955–1956), Hugh Crider (1959–1960), and T. Glenn Caley (1953–1954) review the MOGA "FACTS" brochure, published in 1955.

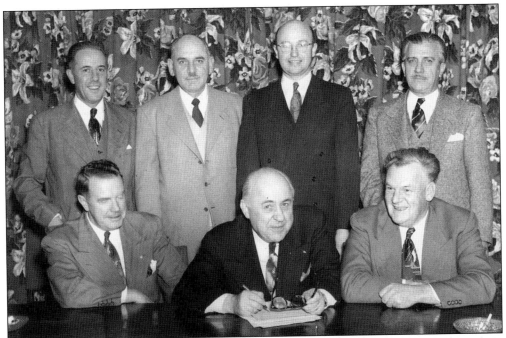

The 1952 MOGA executive committee includes past and present MOGA presidents, seen here from left to right are (first row) Bill Palmer (MOGA executive secretary), J. V. Wicklund Sr. (1952), and T. Glenn Caley (1953–1954); (second row) James C. Foster (1949–1950), O. H. Kristofferson (1965), I. W. Hartman (1951), and Kurt deCousser (1942–1943).

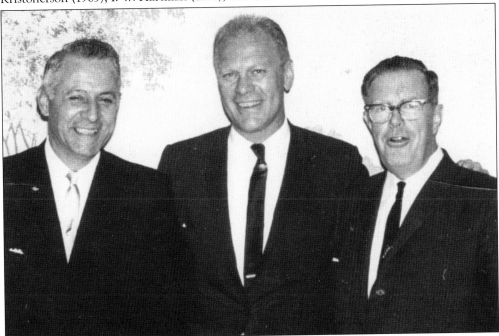

From left to right, John V. Wicklund Jr., MOGA president from 1963 to 1964, is shown with U.S. congressman Gerald Ford and MOGA executive secretary William Palmer at a 1963 MOGA meeting.

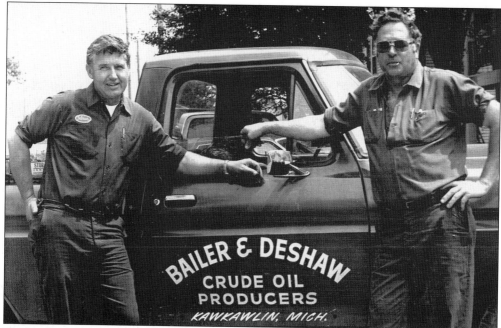

Kawkawlin-based Bailer and DeShaw Crude Oil Producers is one of many long standing Michigan petroleum industry partnerships to span decades. Herman DeShaw, left, and Doug Bailer discovered Saginaw County's Birch Run Dundee Field in 1954. The field operates today at the same intersection of Birch Run Road and Interstate Freeway 75 where the Prime Outlets Shopping Center was built in the 1980s.

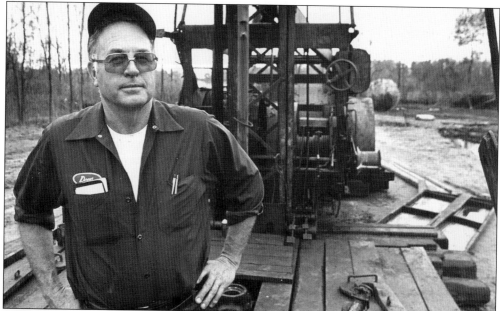

At Prime Outlets at Birch Run Shopping Center, visitors by the thousands pass a working oil well daily next to the Country Inn and Suite's hotel at the center's entrance. Doug Bailer, who continues to work the oil field properties to this day, is shown on the job at another Saginaw County location in 1997.

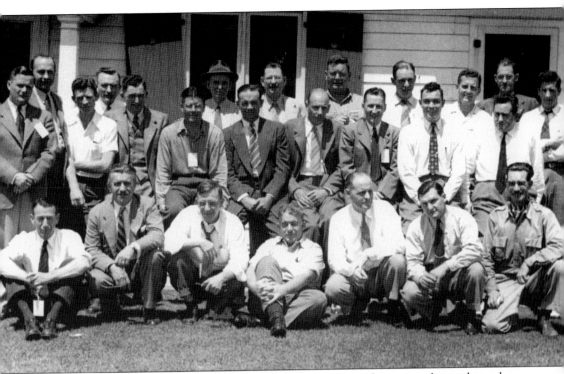

Back in the days when communications were more primitive, information about what others were doing in the competitive oil and gas hunting grounds of Michigan was important. Many companies had scouts to keep an eye on wells of interest being drilled by competitors and report back so future ventures could be planned nearby if possible. Once a week scouts met, as here in 1944 in Mount Pleasant, to share information from their coverage area and hopefully gain more information than they imparted. The scouts seen here, from left to right, are (first row) Chuck Smith (Smith Petroleum), Kurt deCousser (Socony-Vacuum), Rex Grant (Michigan Department of Conservation, Geological Survey Division), Eddie Morgan (Sun Oil Company), Frank Pierce (Sinclair Oil Company), Harry Gaspeny (Pure Oil Company), and George Harris (Consumers Power Company); (second row) William Quigley (Cities Service), J. R. James (Dow), Harold Howell (Muskegon Development), John Johnson (Chapman), Floyd Galloway (Chapman), Dean Shackelford (Pure Oil Company), Art Baldwin (Daily Crude), Dewey Bagwell (Gulf Oil Company), Lindy Berlin (McClanahan), Earl Hess (Superior Oil), Robert Breed (Sohio), Jack Beatty (Gordon Drilling), H. B. Hand (Shell Oil Company), Vance Orr (MacGuire, Inc.), Pete Nicola (Rex Oil Company), Frank Rand (McClanahan Oil Company), R. H. Tompeter Shell Oil Company), and Eddie Pequignot (Gulf Oil Company).

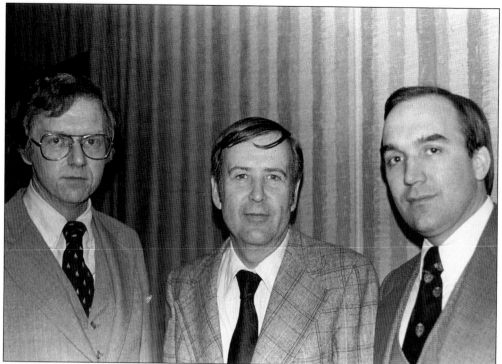

Michigan representative William Bryant, above, with MOGA president Richard J. Burgess (1978–1979) and Michigan representative John Engler are at a 1978 MOGA meeting. In 1990, then-senator John Engler told MOGA "I want to address you next year as Governor of Michigan." Elected later that year, Governor Engler, below with MOGA chairman of the board John R. "Jack" Harkins (1990–1991), kept his word in 1991.

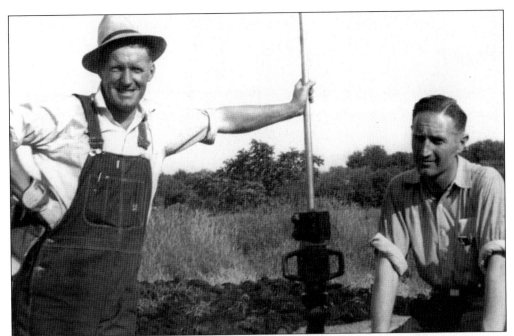

Lester Harris of Clapsaddle and Harris, seen here in 1939 with Charlie Stoll of Utility and Industrial Supply Company, was not only one of the prime movers in the development of the 1938 Bloomingdale Field of Van Buren County but was the second Michigan independent petroleum explorer to pilot his own airplane for more rapid monitoring of his oil field operations.

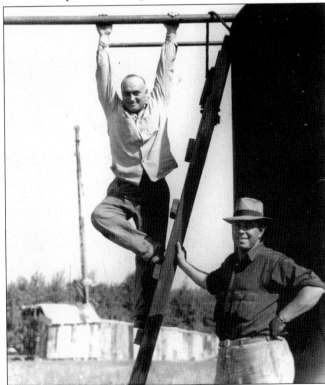

Cliff Perry, who would drill the discovery well of the Albion-Scipio Field in 1957, hangs from a storage tank pipe in 1941 while Danny Stauffer, who was present at the first well ever successfully acidized in 1932 (see page 18) and who would go on establish his own acidizing company, holds the ladder.

Clyde B. Miller, seen at left on the left, and George Miller, on the right, founded Miller Brothers, one of two (with Muskegon Development Company) of the first Michigan oil and gas companies begun in the birth year of Michigan's commercial oil and gas industry. Three generations later the off-springs company still operate in the state. The middle generation, all seen standing below, from left to right, H. Jack Miller, C. John Miller, and Clyde E. "Gene" Miller, pose with George Miller (seated) in the 1960s.

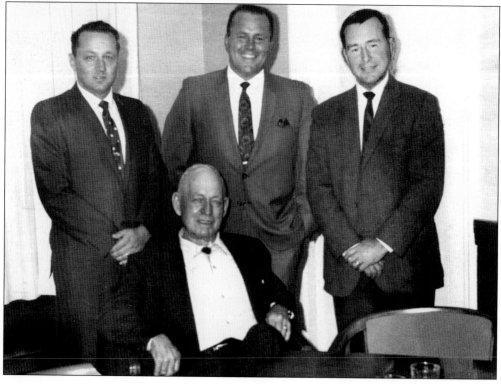

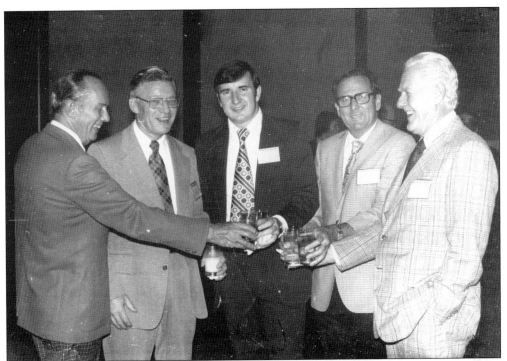

MOGA executive secretary Frank L. Mortl (later executive vice president and finally president as the title of the permanent CEO evolved), center, toasted in 1974 with 1970s elected presidents, from left to right, K. P. Wood (1972–1973), Louis A. Erber (1974–1975), Frank William C. Myler (1968–1969), and G. R. "Rollie" Denison (1970–1971).

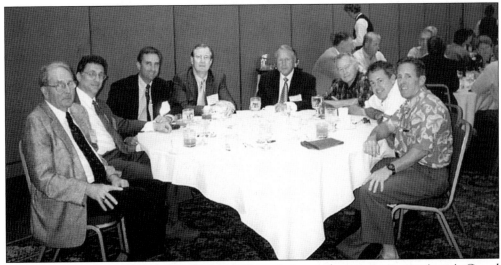

The 2002 Interstate Oil and Gas Compact Commission mid-year meeting at Acme's Grand Traverse Resort drew MOGA notables. Seen here from left to right are William C. Myler (president 1968–1969), Martin Lagina (chairman 1996–1997), William C. Myler Jr. (chairman 1998–1999), Frank L. Mort (permanent MOGA CEO from 1971 to present), C. John Miller (president 1966–1967), Clyde E. "Gene" Miller (president 1976–1977), and third generation Michigan oil industry Kelly Miller and Michael J. Miller (chairman 2000–2001).

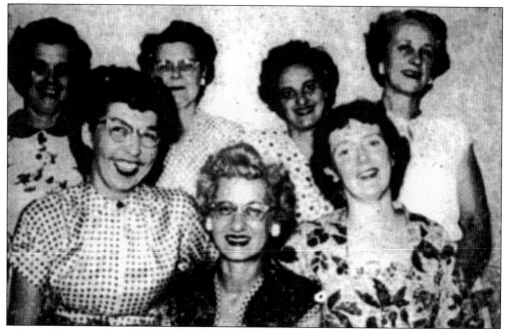

The first Michigan Desk and Derrick Club was formed at Mount Pleasant in 1953 after the 1949 organization of the first Desk and Derrick Club, the nucleus of what would become a national association of oil industry support workers. Seen here, from left to right, are (first row) Lucille Morey, Effie Mae Cook, and Eilene Milloy; (second row) Marion Dean, Thelma Prior, Lola Scribner, and Viola Frost.

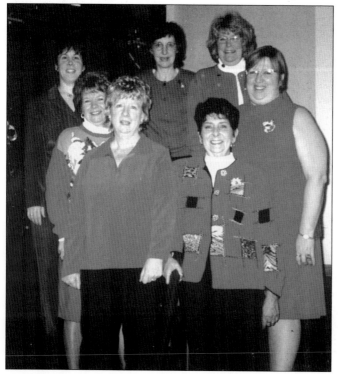

There were once three Desk and Derrick Clubs in Michigan but two have been disbanded, with some membership merging with the remaining Bay Area Desk and Derrick Club (BADD) at Traverse City. BADD 2003 officers are, from left to right, (first row) Kathy Deshasier and Joann Wille; (second row) Melissa Szymanski, Elizabeth (Betty) Wajda, Karen Thomas, Betty Higgins, and Shelly Hildebrand.

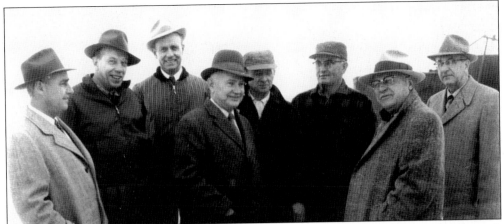

At the drill-in of the Muskegon Development MION No. 1 well in 1958 Newaygo County's Sheridan Township company founder Charles Myler, far left, was joined by, from left to right, John Devine, Earl Hess, Kenneth Hostutler, Hugh Crider, Harold Howell, Paul Hadley, and William Windott. Muskegon Development is Michigan's oldest continuously operating Michigan oil and gas exploration and production firm with the same name. Charles Myler was the driving force behind both the company and the 1927 Muskegon Field discovery.

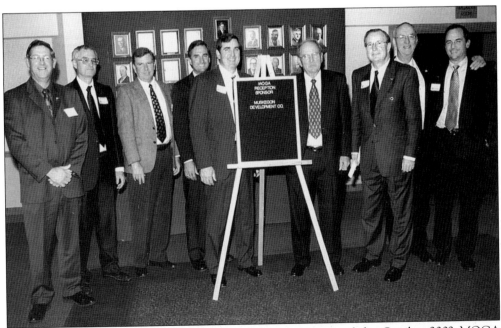

Muskegon Development Company was the reception sponsor of the October 2002 MOGA Annual Membership Meeting, where second and third generation Mylers represented the company. From left to right are MOGA chairman Greg Fogle, Gene Pety, Mike Messburgen, William C. Myler Jr., Jim Myler, William C. Myler, association president Frank L. Mortl, Tom Myler, and Joel Myler.

The *Michigan Oil & Gas News* sponsored a panel discussion of the future of the deep Michigan Basin oil and gas exploration and development at Mount Pleasant in 1977, drawing from the best geological minds on the scene. Seen here, from left to right, are Dr. James Fisher, Michigan State University Geology Department; Bill Mantek, Northern Michigan Exploration; Mike Barratt, then of the Michigan Oil Company; Alvin Hosking, Hosking Geophysical, Inc.; Caspar Cronk, Western Michigan University Geology Department; and Gar Ells, Michigan Department of Natural Resources, Geological Survey Division.

MOGA past presidents and chairmen present at a 1992 meeting are, from left to right, (first row) Richard J. Burgess (1978–1979), H. Jack Miller (1988–1989), and John R. "Jack" Harkins (1990–1991); (second row) Byron J. Cook (1980–1981), Vance Orr Sr. (1984–1985), William C. Myler (1968–1969), Robert J. Mannes (1982–1983), and G. R. "Rollie" Denison (1970–1971).

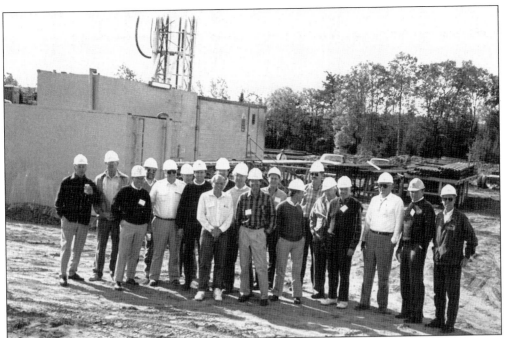

Proving that oil and gas executive life involves more than just the life of the desk set, Miller Brother's H. Jack Miller, MOGA chairman in 1988 and 1989, seen above just left of center in the white shirt with crossed hands at a Miller Brother Grand Traverse production unit, conducted a MOGA Michigan state legislators Northern Michigan oil field operation tour in 1988.

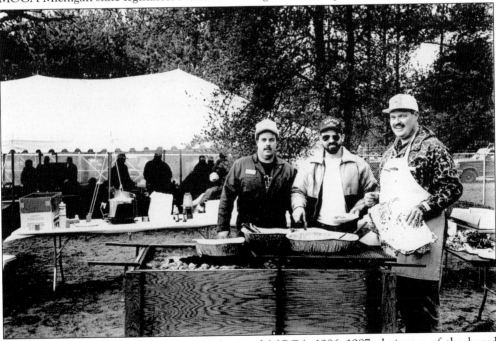

Wolverine Gas and Oil Company president and MOGA 1986–1987 chairman of the board Sidney J. Jansma Jr., right, acted as a co-chef at a 1992 Montmorency County "Thanks A Lot Antrim Workers" pig roast with Randy Parsons, left, and Doug Kimbrill.

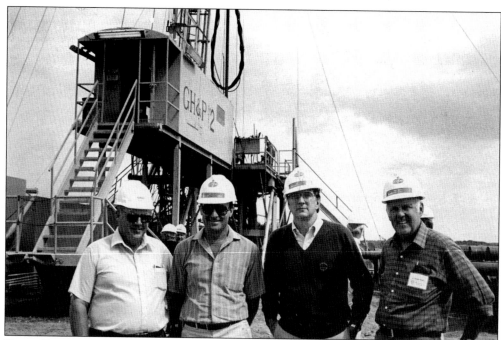

Dwain Provins, drilling contractor, above on the left, is seen with, from left to right, Michigan Department of Natural Resources Geological Survey section chief Tom Segall, MOGA president Frank L. Mortl, and Michigan Department of Natural Resources director Gordon Guyer at a Kalkaska drilling location during a 1986 MOGA-sponsored Michigan regulators informational field trip. Newly-elected 1994 MOGA chairman of the board Gordon L. Wright, below, presents an appreciation plaque to 1992–1993 chairman Vance Orr Jr.

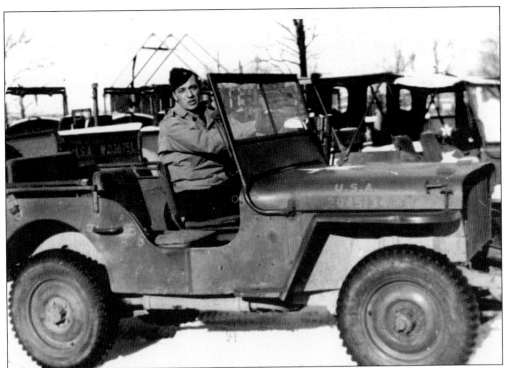

During World War II, Pvt. Hunter Atha was one of the legions of Michigan oilmen who donned a uniform and went off to war. Others manned the home front on the rig floor and its protection. In 1940, detective Charlie Walker, left, and his assistant, below, showed off the latest oil field security, an electric eye.

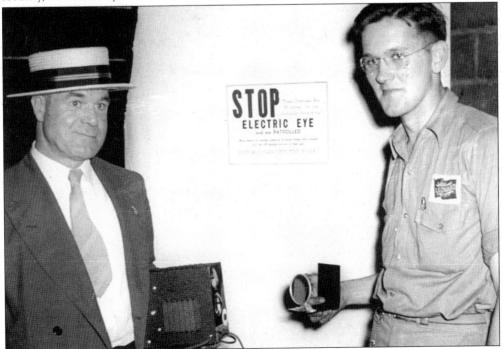

MOGA Annual Picnic and Reunion Golf Outing committee cochairmen, seen at left from left to right, John R. "Jack" Harkins (Lease Management, Inc) and William C. Myler, (Muskegon Development Company) have headed that committee since 1978. Harold McClure Jr., below, pitches to Byron Cook in the annual Producers-Landman softball game while G. R. "Rollie" Denison umpires. The game was a MOGA picnic-day standby before lack of playing field space ended the tradition.

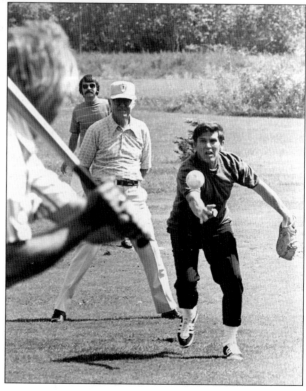

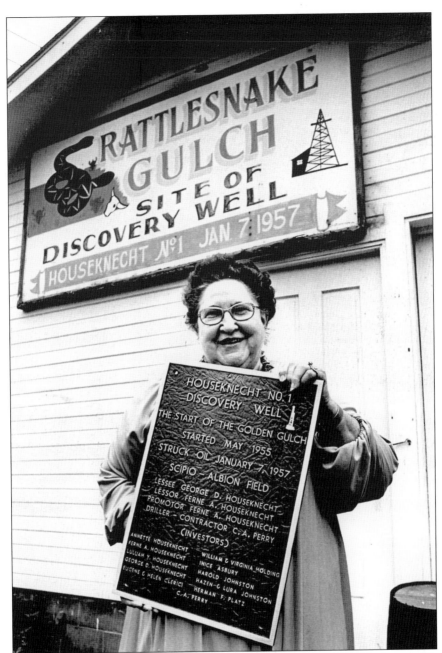

Legend says that a fortune teller told young Ferne Houseknecht that a "black river of oil" lay beneath her property in Hillsdale County. Inspired by this revelation, Houseknecht enlisted contract driller Clifford Perry to secure a drilling permit to drill the Houseknecht 1. Drilling started in May 1954. It took Perry more than two and a half years, between other projects, to drill the hole, with months between deepenings. Persistence paid off on January 7, 1957, when oil was struck at 3,576 feet, ironically in the Trenton-Black River formation, justifying the alleged prediction. There were 734 wells drilled, producing over 150 million barrels of oil and 225 billion cubic feet of natural gas in the Albion-Pulaski-Scipio Trend, a 29 mile long by sometimes mile and a half wide underground "trench of porosity."

Mount Pleasant producer/explorer K. P. Wood was the first president of the Michigan Association of Petroleum Landmen when the organization was formed in 1960. Wood is seen above right with lease acquisition agent Bob Anderson. At a 2005 Michigan Association of (now) Professional Landmen seminar, the organization's officership greeted speaker Gary Worman. Seen below, from left to right, are Mike Flynn, Russ Shinevar, Sandy Hensley, Rebecca Abbott, Worman, and Jim Stachnik.

Tom Roskelley, above, puts the final touches on computerized monitoring equipment on Jennings Petroleum Corporation's dual deep Prairie du Chien/Clinton formation natural gas producer in Goodwell Township of Newaygo County in 1984. Bill Kirschke and Judy Kirk, at right, stand beside the sponsor board for the 1992 Paul Krause Memorial Golf Tournament, an annual fund-raiser that ran several years after Krause's untimely death, with proceeds aiding Krause's wife and children.

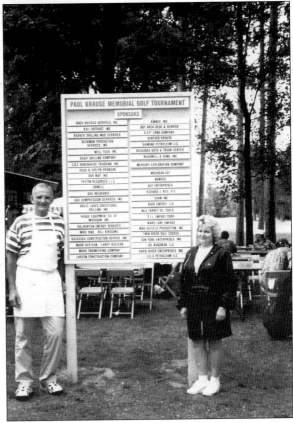

Jack Mortensen, above left, and Ken Hostutler inspect a 1982 well completion job in Douglass Township, Montcalm County. Mortensen, who died April 25, 2006, had Michigan geology experience spanning 65 years. Hostutler was former president of Osceola Refining, later Pipeline Company. Below, a derrickman on the "monkeyboard" of a rig drilling a Missaukee County well, shifts a joint of pipe into the rack in the derrick.

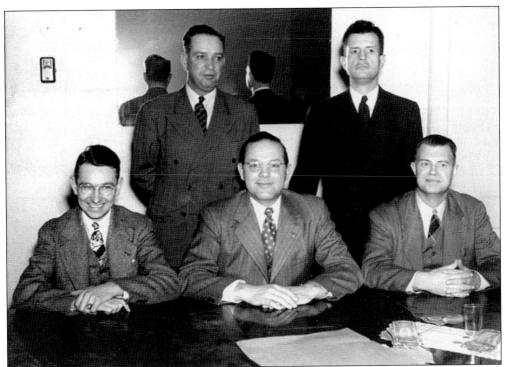

First Michigan chapter American Petroleum Institute (API) officers seen above, from left to right, are Earl G Hartman, Gordon Oil; Lester La Favour, Gulf; William Schultz, Cities Service; William Schoeneck, Ohio Oil; and O. E. "Joe" McAllester, Sun. The 2001 Eastern Section American Association of Petroleum conference, below, in Kalamazoo drew the following, from left to right: Dr William Harrison III, Western Michigan University; Leonard Espinosa, Michigan Basin Geological Society president; MOGA chairman Michael J. Miller; and MOGA president Frank L. Mortl.

Michigan governor Van Wagner and Walter Russell of Mount Pleasant are welcomed to the 1942 MOGA picnic by that organizations legislative secretary Harold McClure Sr.

MOGA president Frank L. Mortl delivers the opening comments at a press conference launching the 2002 Funds for the Future initiative by business and environmental groups to preserve and expand the Michigan Natural Resources Trust Fund. From left to right are Michael Maisner, Michigan Recreation and Park Association; Don Stypula, Michigan Municipal League, Environmental Affairs; John Barratt, Michigan Chamber of Commerce; Mortl; James Goodheart, Michigan United Conservation Clubs; Keith Charters, Michigan Natural Resources Commission; Gordon Guyer, Michigan Natural Resources Trust Fund; and Helen Taylor, Michigan Chapter of the Nature Conservancy.

Six

THE SHORT
AND LONG VIEW

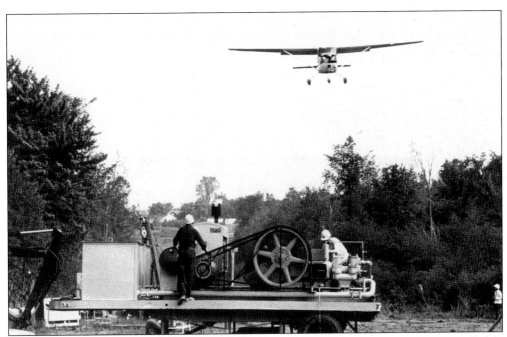

The Flying oilman, Harold M. McClure Jr., comes in low to check out progress of a 1960 Hillsdale County location. The Michigan oil and gas exploration and production industry has always been anxious to expedite matters and independent explorer/producers are no exception. McClure was not the first of the "oilmen with wings" who became pilots for rapid field access. Michigan petroleum pioneer Walter McClanahan (see page 10) was the first, followed by Lester Harris (see page 109), then McClure. Mount Pleasant independent Cliff Collin, a fourth oilman/pilot, was the only producer/explorer to perish while flying his own plane in 1966.

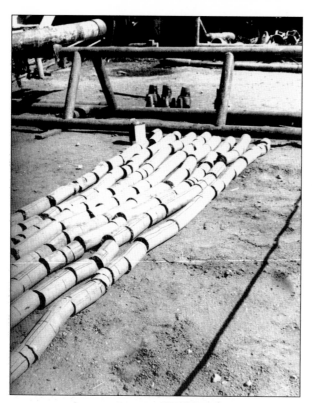

Core samples from a deeper Mason County 1974 Niagaran formation prospect are laid out awaiting closer inspection by geologists. Cores yield valued information about the nature of regional rock characteristics and are kept for years for scientific scrutiny. In 2006, the Michigan Geology Repository for Research and Education opened in Kalamazoo to house thousands of Michigan oil and gas well cores. Cores are sometimes "slabbed," as seen below, for even closer study.

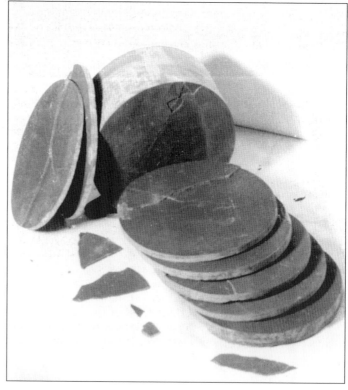

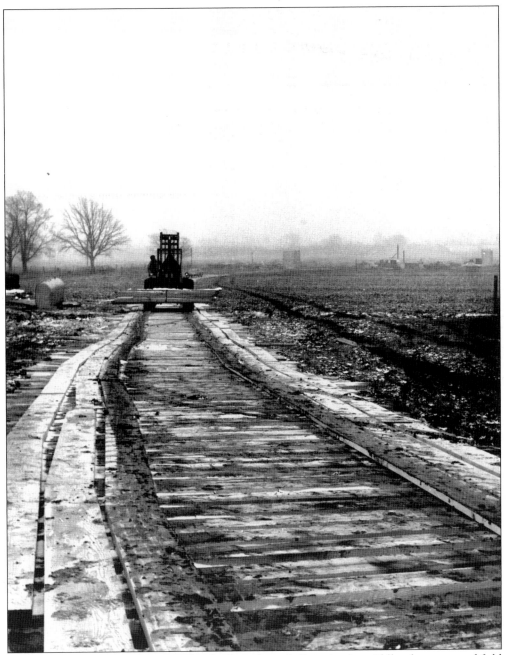

A dozer brings more wood to extend a plank road to a drill site in the middle of a soupy mud field of 1939 in Ottawa County. The science of finding more oil and gas in Michigan to help satisfy the voracious energy appetite of modern life has seen many technical, regulatory, environmental, and social evolutions in its first eight decades. The industry at large continues finding new ways to learn from yesterday, and to put the lessons of the past to work today to find the road to a brighter domestic petroleum energy production future, one well "plank" at a time.

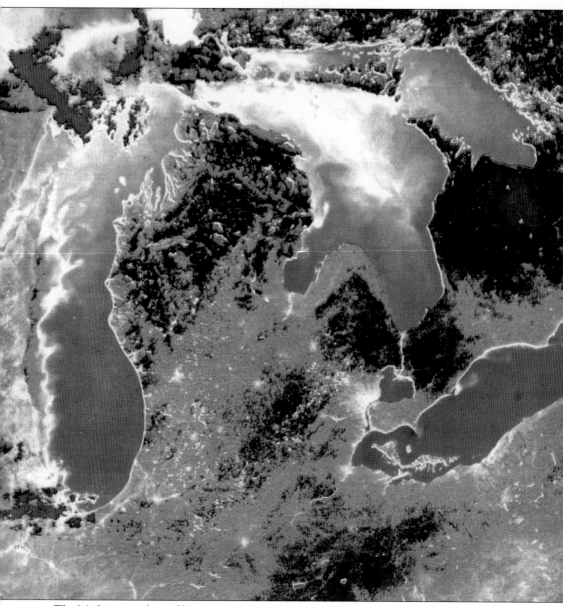

The Michigan geological basin is seen from the air. Some scientific work is being done to translate satellite imagery into a useful petroleum exploration tool. Through all the scientific strides that have been made in helping to unlock the earth's secrets in the search for oil and gas, nothing has yet been developed to tell for sure what is down there without drilling a straight, angled, or horizontal hole in the ground. In Michigan, that search will continue for the foreseeable future because Michigan has abundant petroleum energy reserves and resources ready for orderly development.